PHOTOSECRETS
NEW YORK

WHERE TO TAKE PICTURES

BY
ANDREW HUDSON

*"A good photograph
is knowing where to stand."*
— Ansel Adams

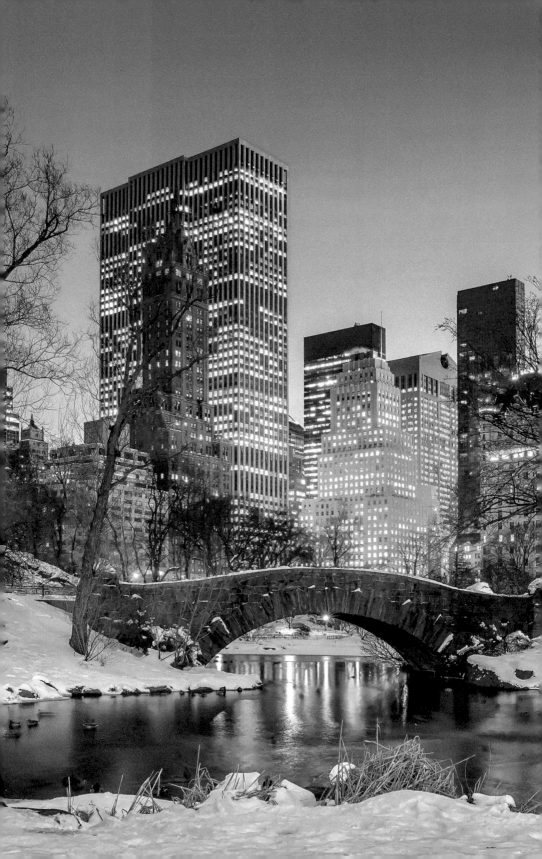

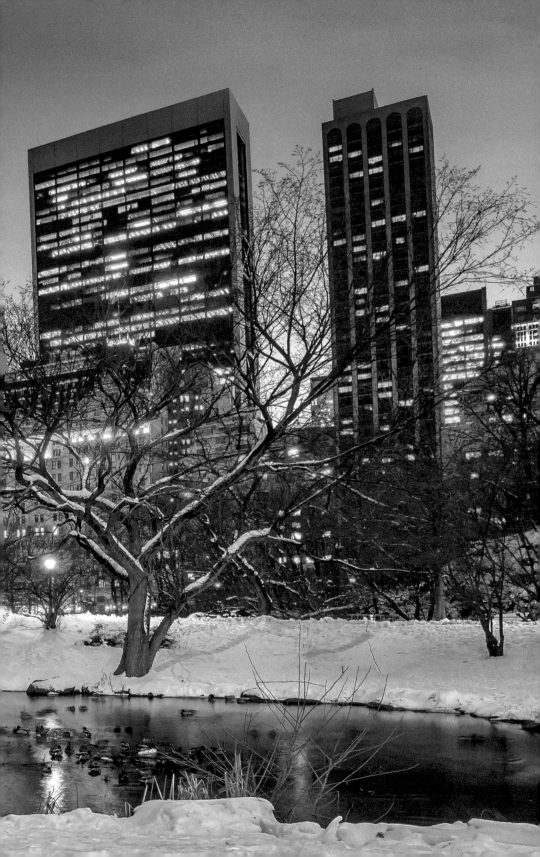

 Foreword By Bob Krist

A GREAT TRAVEL photograph, like a great news photograph, requires you to be in the right place at the right time to capture that special moment. Professional photographers have a short-hand phrase for this: "F8 and be there."

There are countless books that can help you with photographic technique, the "F8" portion of that equation. But until now, there's been little help for the other, more critical portion of that equation, the "be there" part.

To find the right spot, you had to expend lots of time and shoe leather to research the area, walk around, track down every potential viewpoint, see what works, and essentially re-invent the wheel.

In my career as a professional travel photographer, well over half my time on location is spent seeking out the good angles. Andrew Hudson's PhotoSecrets does all that legwork for you, so you can spend your time photographing instead of wandering about. It's like having a professional location scout in your camera bag. I wish I had one of these books for every city I photograph on assignment.

PhotoSecrets can help you capture the most beautiful sights with a minimum of hassle and a maximum of enjoyment. So grab your camera, find your favorite PhotoSecrets spots, and "be there!"

Bob Krist has photographed assignments for *National Geographic, National Geographic Traveler, Travel/Holiday, Smithsonian,* and *Islands.* He won "Travel photographer of the Year" from the Society of American Travel Writers in 1994, 2007, and 2008 and today shoots video as a Sony Artisan Of Imagery.

For *National Geographic,* Bob has led round-the-world tours and a traveling lecture series. His book *In Tuscany* with Frances Mayes spent a month on *The New York Times'* bestseller list and his how-to book *Spirit of Place* was hailed by *American Photographer* magazine as "the best book about travel photography."

After training at the American Conservatory Theater, Bob was a theater actor in Europe and a newspaper photographer in his native New Jersey. The parents of three sons, Bob and his wife Peggy live in New Hope, Pennsylvania.

☕ Contents

📍 New York

The **City of New York** resides where the Hudson River empties into the natural harbor of Upper New York Bay, home of the Statue of Liberty. Most of the sights are on Manhattan island, with other views in Brooklyn and Queens, and from the New Jersey waterfront.

📍 Upper New York Bay

Upper New York Bay includes the Statue of Liberty on Liberty Island, and the immigrant inspection station of Ellis Island, which together form the Statue of Liberty National Monument. The Bay is crossed by ferries with views of the Lower Manhattan skyline.

📍 Lower Manhattan

Lower Manhattan is the historical and financial heart of New York. Sights include Wall Street, the World Trade Center site, and Brooklyn Bridge.

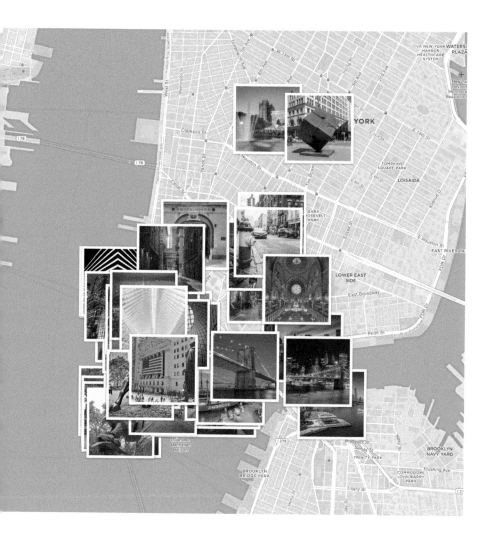

📍 Midtown Manhattan

Midtown Manhattan includes the Empire State Building, the Chrysler Building, Times Square, Rockefeller Center, and the High Line.

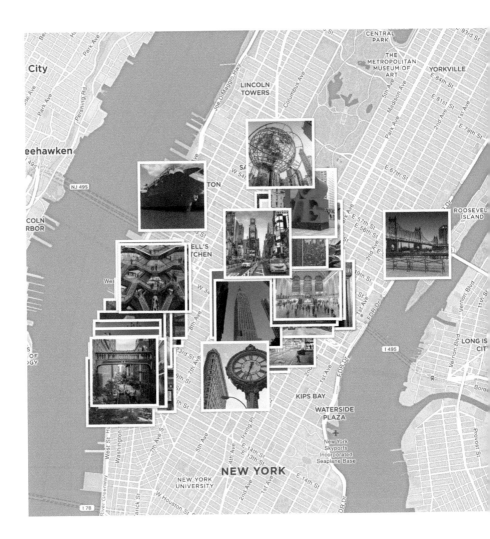

📍 Central Park

Central Park opened in 1857 as an 843-acre public greenery and retreat from the urban surroundings. The beautifully sculpted landscape includes romantic bridges and lakes.

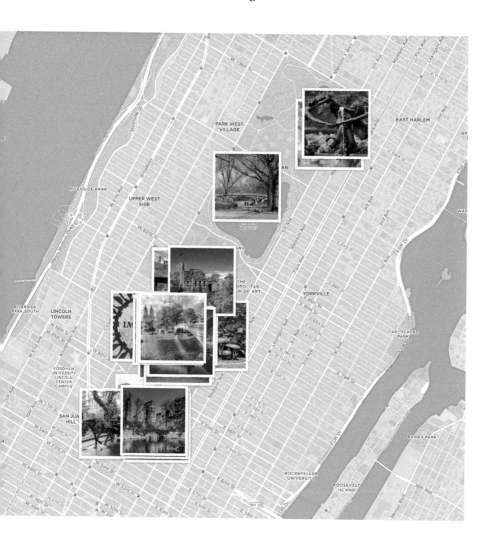

Upper Manhattan includes museums around Central Park, the 'Seinfeld' diner, and the Little Red Lighthouse on the northern tip of Manhattan.

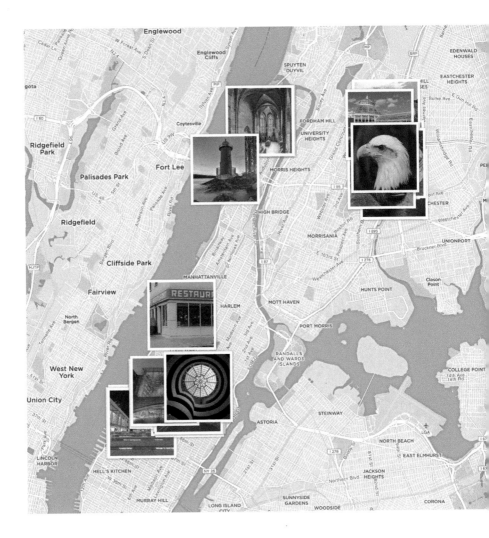

📍 Greater New York

Greater New York includes the New York boroughs of Brooklyn and Queens, and Manhattan views from the New Jersey waterfront.

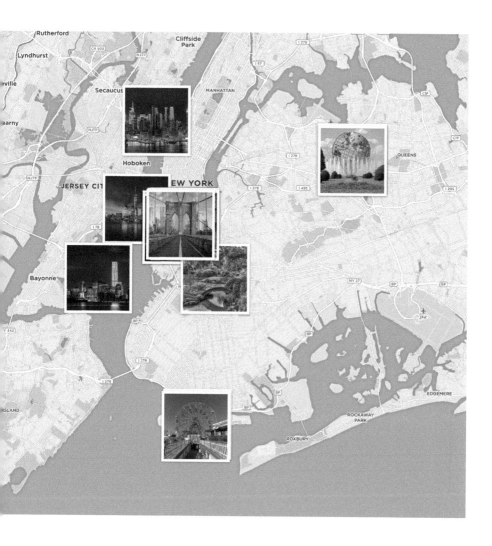

ℹ️ Introduction

New York beckons your camera with the icons of America: the Statue of Liberty and the skyscrapers of Manhattan. Capture the excitement of the ultimate big city, with bustling Times Square and Wall Street, and from towering observation decks on One World Trade Center, the Empire State Building, and Rockefeller Center.

Most of the sights are in an area eight miles long and four miles wide, all easily accessed by public transport subway, ferries, and walking paths. We start our journey in the south, at the can't-miss Statue of Liberty, and move north up Manhattan island, where most of the east-west streets are conveniently numbered. At 59th Street we reach Central Park with a welcome respite of greenery, then we head out to the city's boroughs, with skyline views from the Manhattan Bridge, Brooklyn Bridge Park, and the waterfront of New Jersey.

Officially called the **City of New York**, the "Big Apple" is also known as **New York City** (NYC), **New York** (NY), and, since it is part of the state with the same name, **New York, New York**.

Humans were in the area around 9,000 years ago and by the 1600s, there may have been about 15,000 Lenape Native Americans in 80 settlement sites, cultivating vegetation and fishing in the bay. They called the main island 'manaháhtaan' meaning "place for gathering the (wood to make) bows" (for its grove of strong hickory trees), and made a trail along the island's length, today's Broadway.

The first documented European visit was by a French ship in 1524 captained by Florentine explorer Giovanni da Verrazzano. Sailing the coastline, he moored by today's Verrazzano-Narrows Bridge and saw what appeared to be a large lake, the Upper New York Bay.

In 1609, a Dutch ship led by Englishman Henry Hudson explored the Bay and the main island was recorded as 'Manna-hata.' Hudson sailed the river that now bears his name up to present-day Albany and bought valuable beaver pelts. The Dutch claimed the area, establishing a fur-trading post on the western shore of Manhattan Island in 1613, and Beverwijck ("Beaver District") in 1614, 145 miles (230 km) up river.

Dutch origins exist in many area names, such as Staten Island ("States Island"), Coney Island (from Konijnen Eiland, "Rabbit Island"), Greenwich Village (Greenwijck, meaning "pine wood quarter"), Bowery (bouwerij, "farm"), and Dutch towns gave their names to Brooklyn (from Breukelen), Harlem (Haarlem), and Flushing (from Vlissingen).

In 1625, the capital of New Netherland was recognized as the

southern tip of Manhattan, which controlled the valuable river commerce. The star-shaped Fort Amsterdam was built where the U.S. Custom House now stands (today's Battery references the cannons), and today's Wall Street had a twelve-foot-high wall across the island to defend from land attacks. But the defenses were no match against four English frigates that arrived in 1664 — as the maritime rival was capturing Dutch trading posts in Africa and America — and the city was ceded to England. New Netherland, New Amsterdam, and Beaver District were all renamed after the king's brother (and the Navy's commander), the "Duke of York and Albany" (combining a city in England and a region of Scotland). Hence, New York (for the state and the state's largest city) and Albany (for the state capital).

During the American Revolutionary War, Manhattan was at the heart of the New York Campaign and became the first capital under the newly enacted Constitution of the United States in 1789. Due to Alexander Hamilton's work as the first Secretary of the Treasury, New York grew as an economic center, and benefitted from the opening of the Erie Canal in 1825, which connected the Atlantic port to the vast agricultural markets of the Midwestern United States and Canada. By 1810, New York City, had surpassed Philadelphia as the largest city in the United States.

After the Civil War, the rate of immigration from Europe grew steeply and Manhattan became the first stop for millions seeking a new life in the United States, a role acknowledged by the dedication of the Statue of Liberty in 1886, a gift from the people of France. In 1857, Central Park was established, now the country's most visited urban park and one of the most filmed locations in the world. Despite the Great Depression, some of the world's tallest skyscrapers were completed in Manhattan during the 1930s, including Art Deco masterpieces that are still part of the city's skyline, including the Empire State Building, the Chrysler Building, and 30 Rockefeller Plaza.

Today, New York awaits your camera.

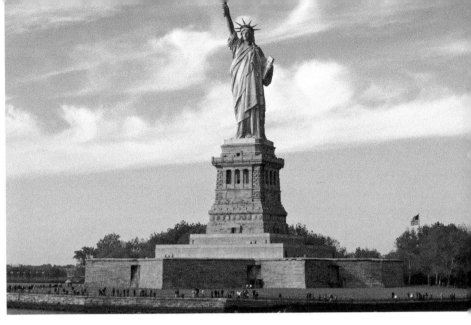

The **Statue of Liberty** is the icon of New York, and of freedom. Officially called **Liberty Enlightening the World**, this colossal copper statue is 151 feet tall (46 m). Based on the Roman goddess Libertas, the robed figure holds a torch, and a tablet inscribed with the date of the U.S. Declaration of Independence. A broken chain lies at her feet as she walks forward.

Dedicated in 1886 as a gift from the people of France, Liberty was designed by French sculptor Frédéric Auguste Bartholdi with a metal frame by Gustave Eiffel.

The Statue stands on Liberty Island in Upper New York Bay. These views are from the **Statue Cruises ferry** which is the only way to visit the island. There are two departure locations: The Battery in New York, and Liberty State Park in New Jersey. Book ahead at statuecruises.com.

✉ **Addr:**	1 Battery Place, New York NY 10004	⚲ **Where:**	40.688119 -74.0428125
❓ **What:**	Views	⏲ **When:**	Morning
👁 **Look:**	Northwest	W **Wik:**	Statue_of_Liberty

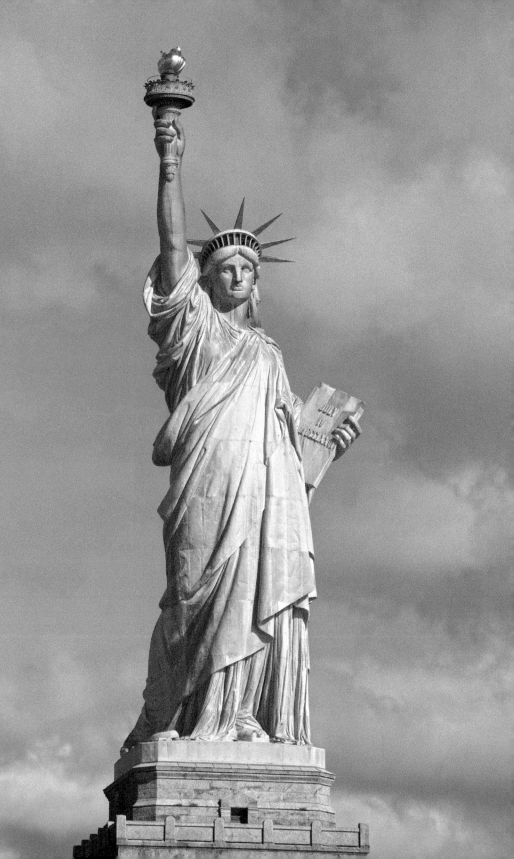

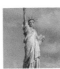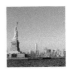

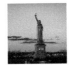

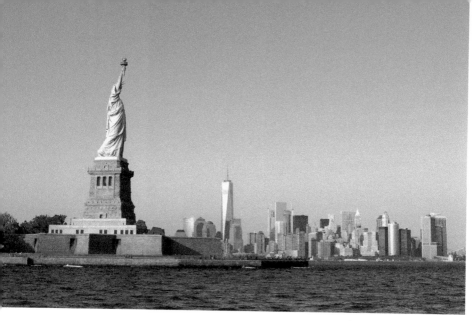

From a ferry southwest of the statue, Lower Manhattan is in the background.

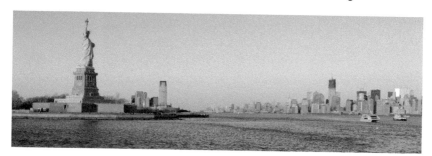

From south of the island, the background includes Exchange Place in New Jersey.

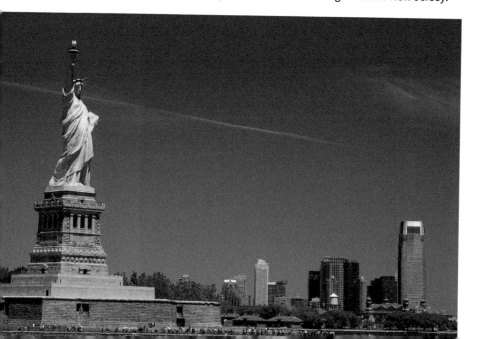

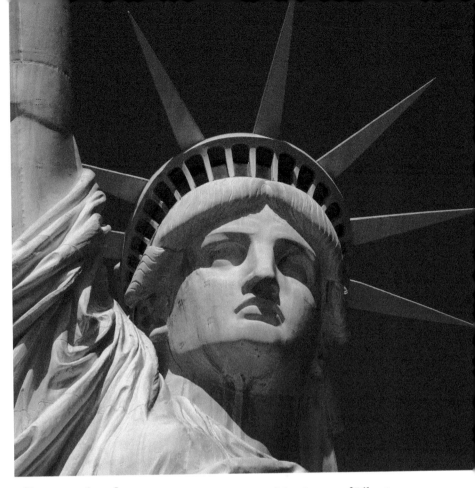

Liberty Island provides powerful views of the Statue of Liberty. There is a path around the east tip of the island, which is about 300 feet (100 m) from Liberty's face. Morning is best as the statue faces east-southeast.

✉ **Addr:**	Liberty Island, New York NY 10004	♥ **Where:**	40.688587 -74.044221
◐ **When:**	Morning	◉ **Look:**	North-northwest
W **Wik:**	Liberty_Island		

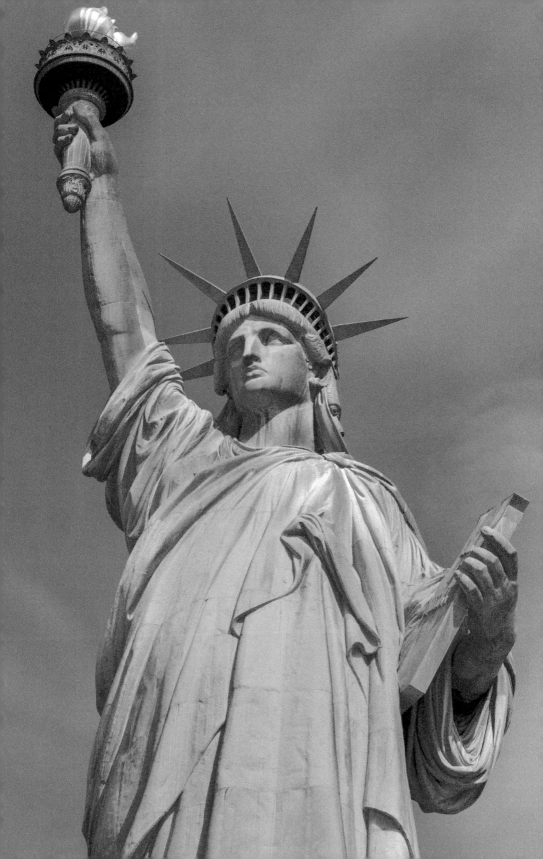

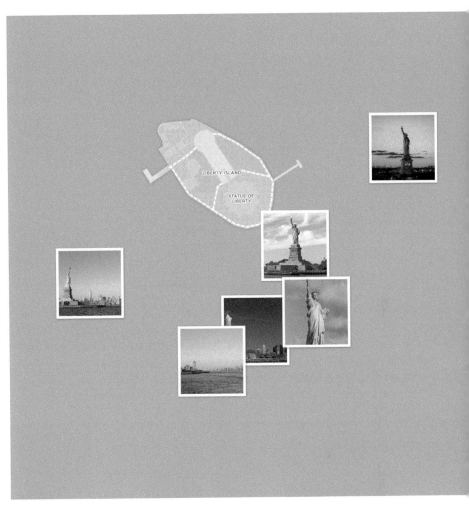

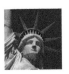

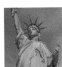

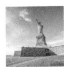

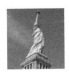

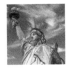

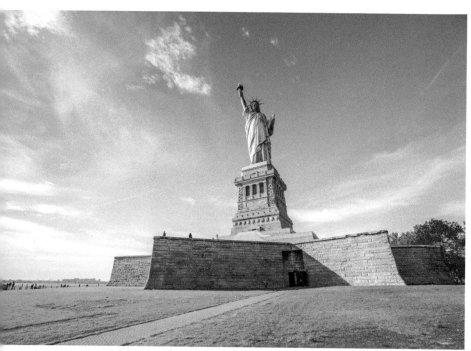

Above: The Statue of Liberty stands on the star-shaped Fort Wood, completed in 1811 to protect New York from British invasion. Below: From the walkway on top of Fort Wood, you can take a dynamic diagonal shot of the torch and tablet.

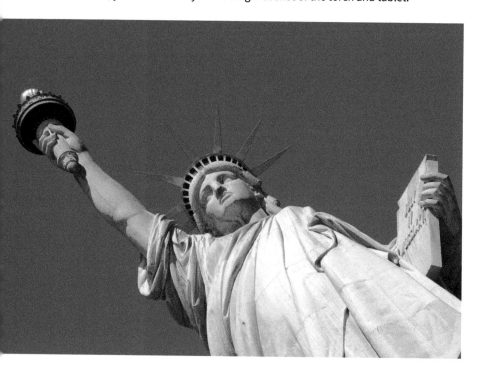

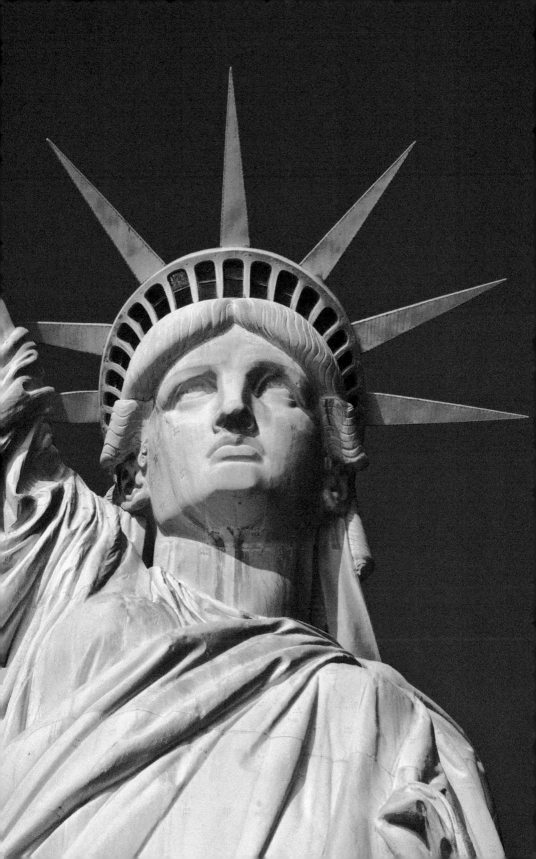

The **Statue of Liberty Museum** is inside the star-shaped Fort Wood, under the Statue. You can see the original torch and portions of the artwork. Outside is a sculpture garden with a figure of Liberty's French sculptor, Frederic Auguste Bartholdi.

A new museum is under construction.

✉ **Addr:**	Liberty Island, New York NY 10004	♀ **Where:**	40.689494 -74.044754
❓ **What:**	Museum	🕐 **When:**	Anytime
👁 **Look:**	South-southeast	W **Wik:**	Liberty_Island#Museum

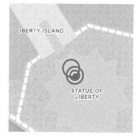

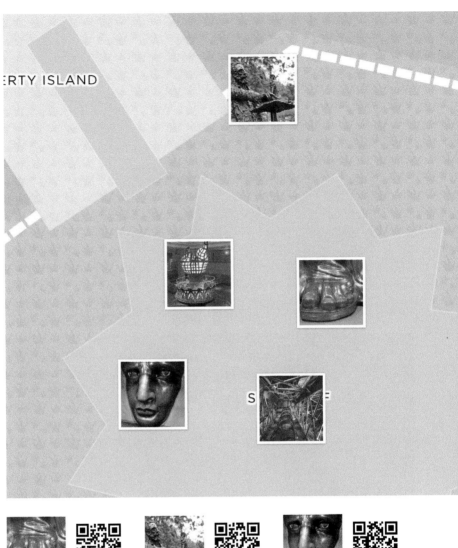

S F

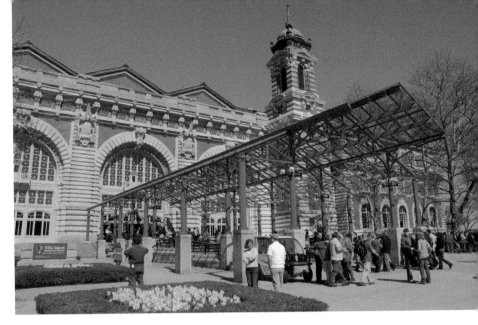

Ellis Island was the gateway for millions of immigrants to the United States as the nation's busiest immigrant inspection station from 1892 to 1954. A visit here is included in the Statue Cruises ferry trip.

The covered Immigration Pathway leads to the main Registry Building, with a beautiful vaulted interior.

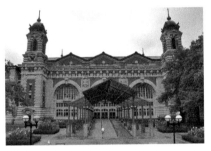

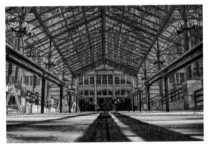

✉ **Addr:**	Ellis Island, New York NY 10004	♀ **Where:**	40.6988486 -74.0401648	
❷ **What:**	Building	◑ **When:**	Afternoon	
👁 **Look:**	East-northeast	W **Wik:**	Ellis_Island	

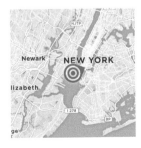

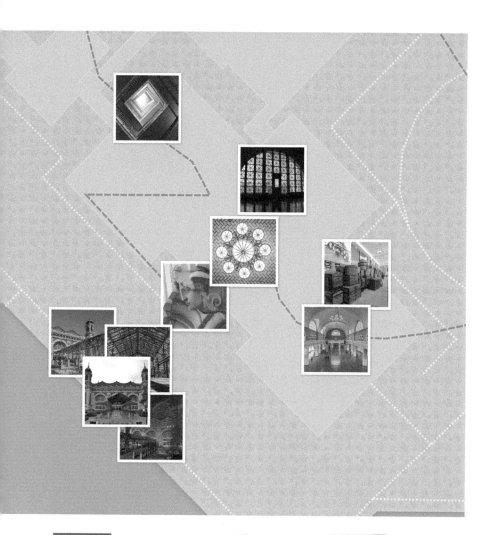

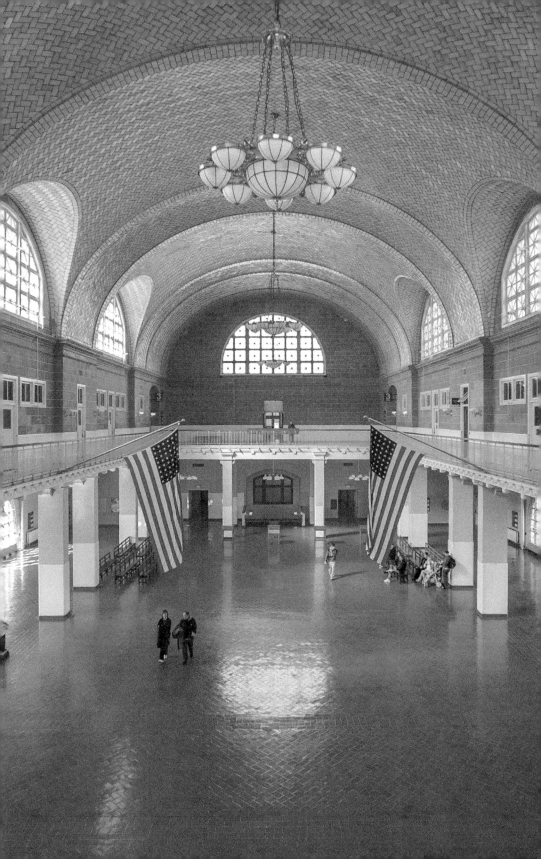

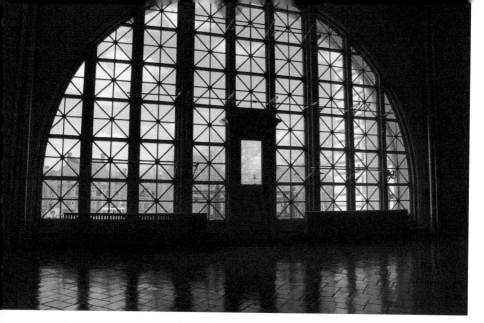

Above and below: Registry Building window, chandelier and luggage exhibit.

 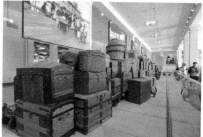

Below: A spiral staircase at the northwest end of the Registry Building.

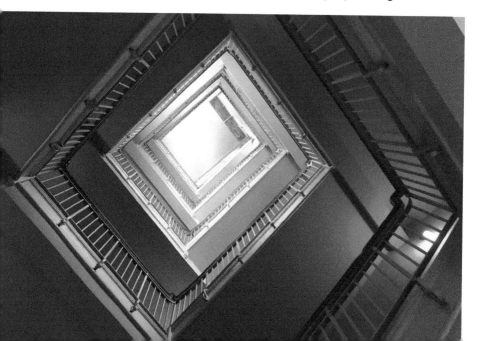

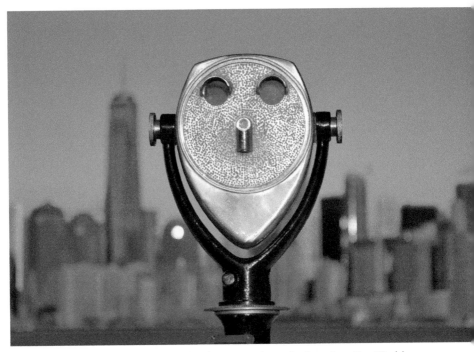

Above: From the north side of Ellis Island, a tower viewer looks out on One World Trade Center and Lower Manhattan. Below: The circular American Immigrant Wall of Honor can be used as a close foreground for the skyline background.

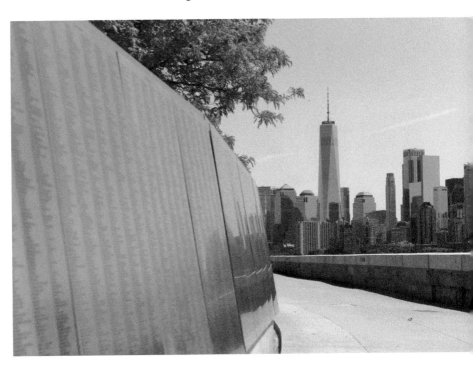

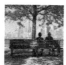

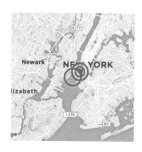

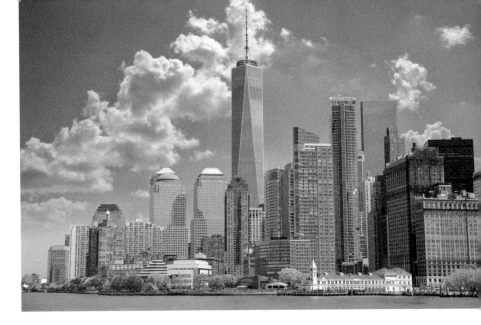

The **Liberty Island Ferry from New York** has a view of Lower Manhattan with One World Trade Center and Battery Park City. Use a polarizer filter to make the sky a deep blue and reduce glare on the buildings and water.

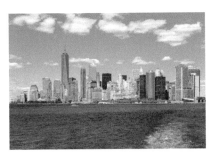

✉ **Addr:**	Battery/Liberty Island Ferry, New York NY 10004	♀ **Where:**	40.7023451 -74.0209925
◑ **When:**	Afternoon	👁 **Look:**	North-northeast
↔ **Far:**	1.33 km (0.82 miles)		

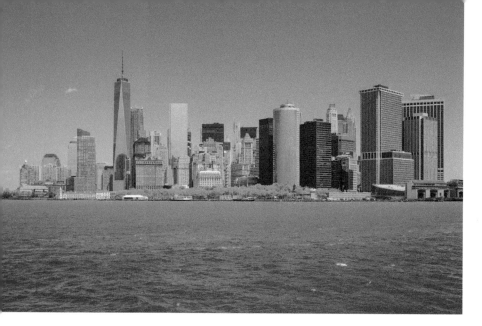

From the Staten Island Ferry you can photograph Lower Manhattan with One World Trade Center (tall, left), the Battery (green, center) and 17 State Street (blue, center/right). The trip takes about 25 minutes each way and is a good backup if you can't get a spot on the Liberty Island ferry. There are similar views from Governor's Island.

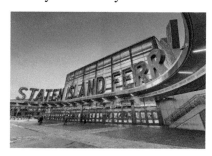

✉ **Addr:**	4 South St, New York NY 10004	♀ **Where:**	40.6967289 -74.020548	
◑ **When:**	Afternoon	◉ **Look:**	North-northeast	
W **Wik:**	Staten_Island_Ferry			

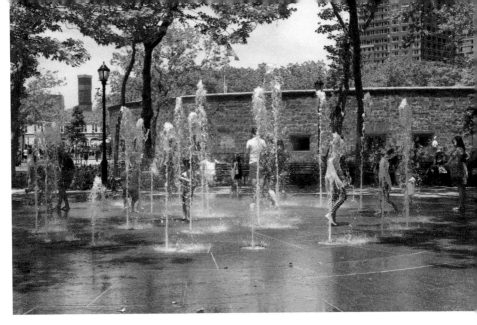

The Battery is a park on the southern tip of Manhattan. Formerly known as Battery Park, the area includes the 1812 Castle Clinton (above); an eagle on the East Coast Memorial (below left); and the Korean War Memorial by *The Sphere*, which stood at the center of the World Trade Center plaza a few blocks away.

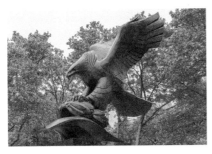

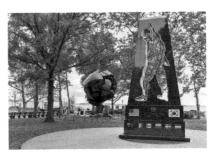

✉ **Addr:**	The Battery, New York NY 10004	♥ **Where:**	40.703717 -74.016094
❷ **What:**	Park	◑ **When:**	Afternoon
👁 **Look:**	North	W **Wik:**	The_Battery_(Manhattan)

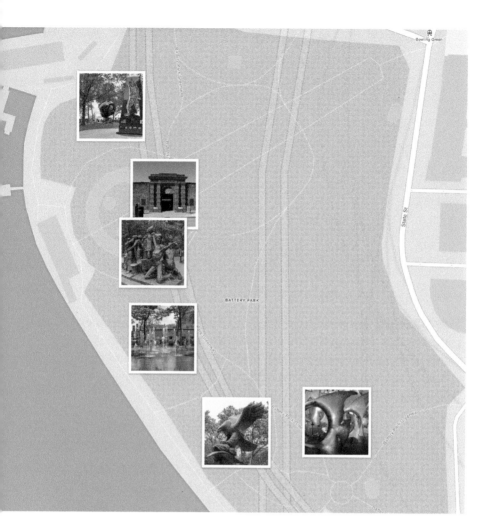

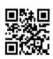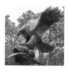

The **Alexander Hamilton U.S. Custom House** is a Beaux-Arts masterpiece by Cass Gilbert. Built in 1902–1907 for the Port of New York, the building now houses part of the National Museum of the American Indian and the National Archives.

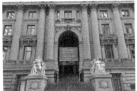

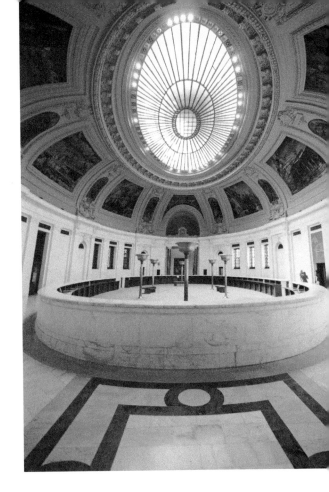

In the center, is a spectacular rotunda under a noble Roman dome.

✉ **Addr:**	1 Bowling Green, New York NY 10004	♀ **Where:**	40.704172 -74.013743	
❷ **What:**	Rotunda	◐ **When:**	Anytime	
👁 **Look:**	South	Ⓦ **Wik:**	Alexander_Hamilton_U.S._Custom_House	

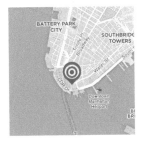

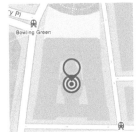

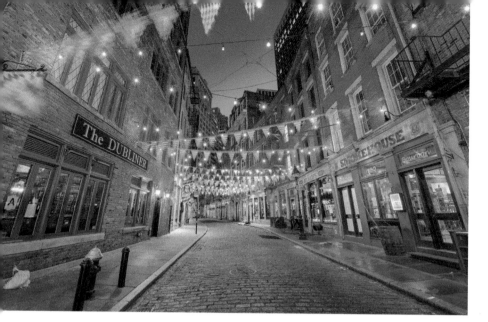

Stone Street is one of New York's oldest roads, established around 1626–32 when Dutch colonists named it Hoogh Straet ("High Street"). This was the first paved road in Nieuw Amsterdam and was renamed for its cobblestone (technically Belgian block) surface. Enjoy the pedestrian-only historic district, one of Downtown's liveliest scenes.

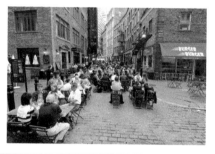

✉ **Addr:**	Stone Street, New York NY 10004	♀ **Where:**	40.704226 -74.010509
❷ **What:**	Cobblestone street	◑ **When:**	Afternoon
👁 **Look:**	Northeast	W **Wik:**	Stone_Street_(Manhattan)

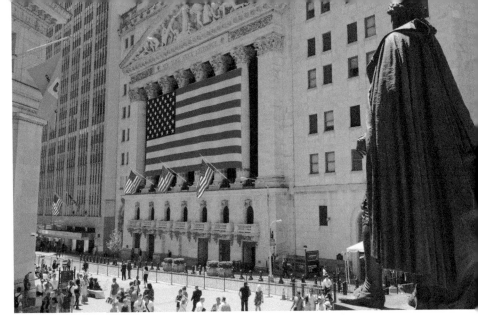

Wall Street is an another original Dutch street which had a wall forming the northern boundary of the New Amsterdam settlement. George Washington became president here and a statue of him at Federal Hall overlooks the New York Stock Exchange (above), making Wall Street synonymous with finance.

✉ **Addr:**	Wall Street & Broad Street, New York NY 10006	♥ **Where:**	40.707115 -74.010418
❷ **What:**	Street	◑ **When:**	Anytime
◉ **Look:**	West-southwest	W **Wik:**	Wall_Street

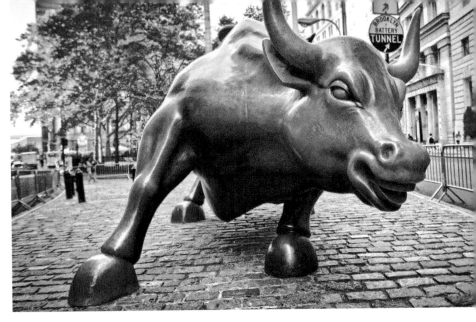

Charging Bull is a 7,000-pound bronze sculpture by Italian American sculptor Arturo Di Modica. Originally installed without permission in front of the New York Stock Exchange in 1989, the bull was moved to Bowling Green park. Since 2017, artist Kristen Visbal's *Fearless Girl* has stared down the bull.

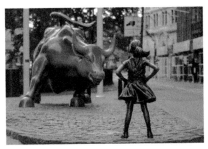

✉ **Addr:**	Bowling Green, New York NY 10004	📍 **Where:**	40.705665 -74.013375	
❓ **What:**	Sculpture	◑ **When:**	Morning	
👁 **Look:**	South-southwest	W **Wik:**	Charging_Bull	

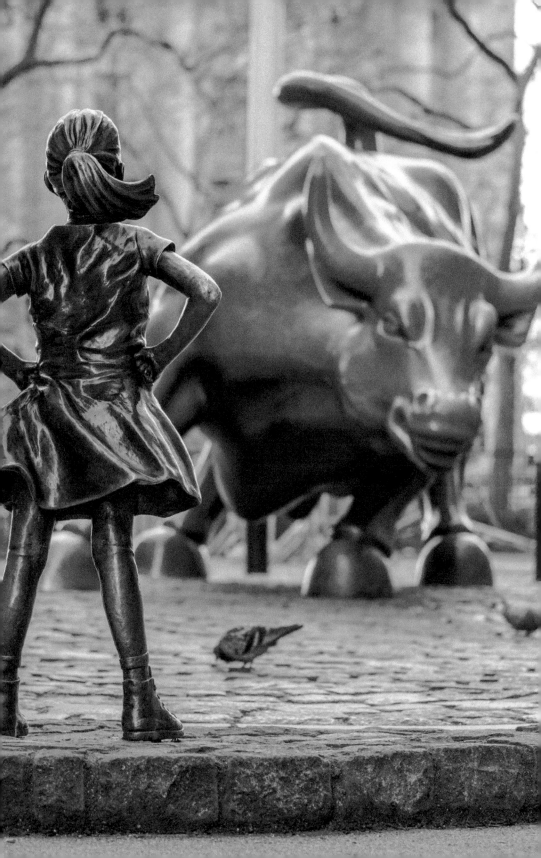

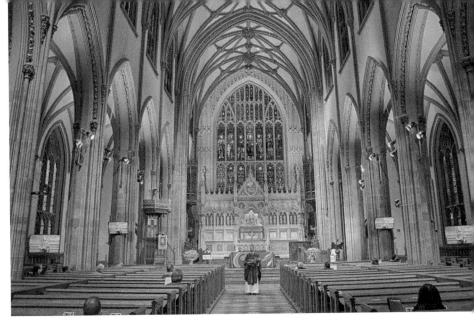

Trinity Church stands at the end of Wall Street — how ironic. Founded in 1696, the current Gothic Revival church with a soaring nave and spire was built in 1846 as America's tallest building.

To the north and south are scenic cemeteries, where Alexander Hamilton and other luminaries are buried.

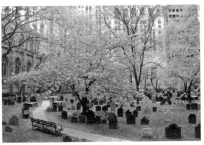
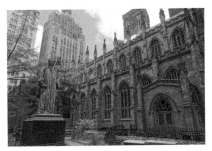

✉ **Addr:**	75 Broadway, New York NY 10006	⍟ **Where:**	40.707957 -74.011903
❷ **What:**	Church	⏱ **When:**	Morning
👁 **Look:**	West-northwest	Ⓦ **Wik:**	Trinity_Church_(Manhattan)

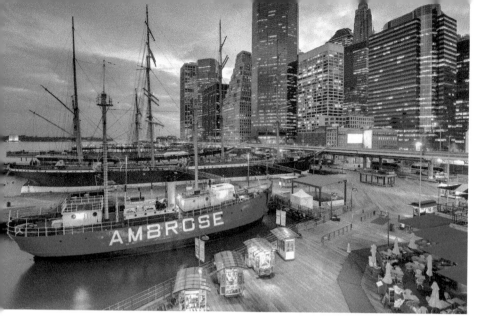

South Street Seaport is an area for fish and ships. With vintage architecture dating from its heydey as a global trading port, and a revitalized landscape for shopping and dining, the Seaport District is a photographer's delight with views of the East River, Brooklyn Bridge, and Brooklyn Heights.

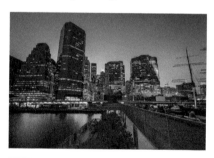
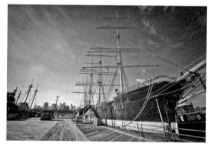

✉ **Addr:**	19 Fulton St, New York NY 10038	♥ **Where:**	40.705297 -74.001878
❓ **What:**	Area	☽ **When:**	Anytime
👁 **Look:**	West	W **Wik:**	South_Street_Seaport

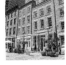

 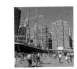 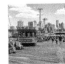

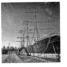

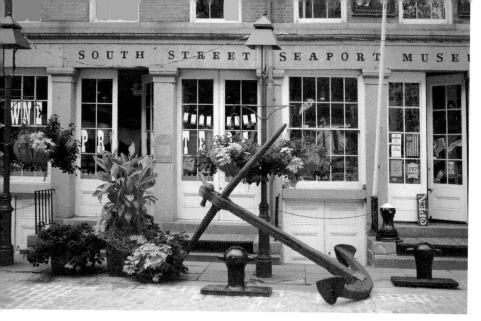

Above and below left: Water Street has a museum and the 1913 Titanic Lighthouse.

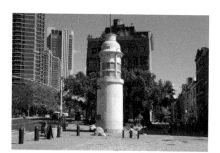

Below: At Pier 16 is the 1885 *Wavertree*, the largest iron ship afloat.

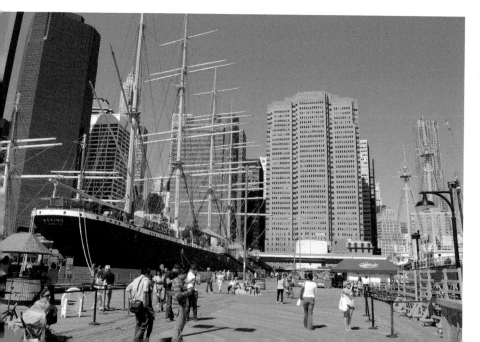

Red Cube is a descriptively-named 1968 artwork by Japanese American artist Isamu Noguchi. Poised precariously on one corner, the 24-foot-high (7 m) Cube could be a die rolling past 140 Broadway (formerly known as the Marine Midland Building and HSBC Bank Building).

The Red Cube lends itself to a fun people shot. Your friends can pretend to be pushing or holding up the giant block.

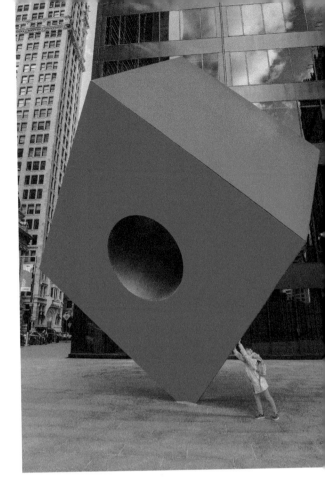

✉ **Addr:**	140 Broadway at Exchange Place, New York NY 10005	♀ **Where:**	40.706771 -74.012526
❷ **What:**	Sculpture	☾ **When:**	Afternoon
👁 **Look:**	North	W **Wik:**	Isamu_Noguchi

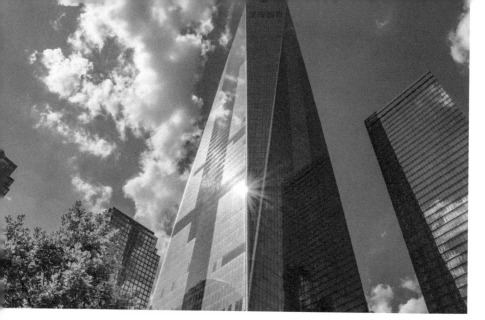

One World Trade Center

One World Trade Center is the tallest building in the United States, the tallest building in the Western Hemisphere, and the sixth-tallest in the world.

Formerly known as the Freedom Tower for its total height of 1,776 feet (541 m), One WTC anchors the rebuilt World Trade Center complex.

The photo above is from the adjacent 9/11 Memorial, east of the North Pool. The facing photos are, clockwise from top left: The west entrance to the observatory; from Battery Park City with Brookfield Place; from the Club Quarters Hotel WTC North Terrace; from the 9/11 Memorial South Pool. The full-page photo is from Fulton Street at Nassau Street — as far from the tower as it is tall — with the old buildings framing the new.

✉ **Addr:**	285 Fulton St, New York NY 10007	♀ **Where:**	40.711858 -74.012513
❷ **What:**	Skyscraper	◑ **When:**	Morning
👁 **Look:**	North-northwest	W **Wik:**	One_World_Trade_Center

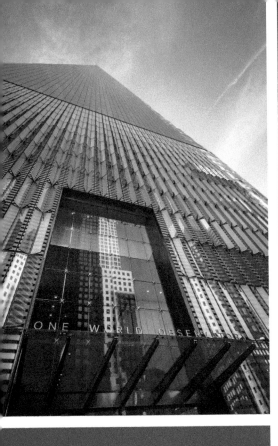
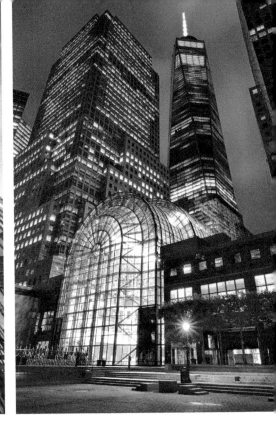
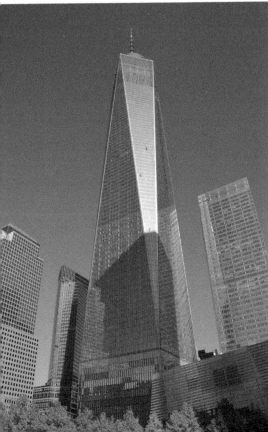
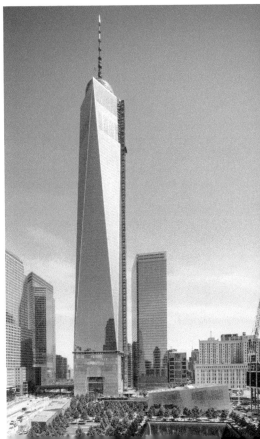

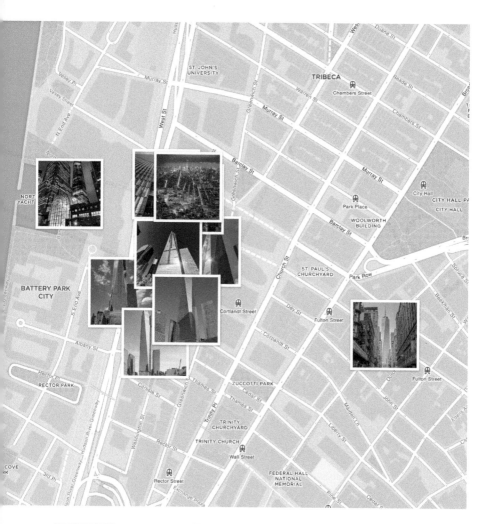

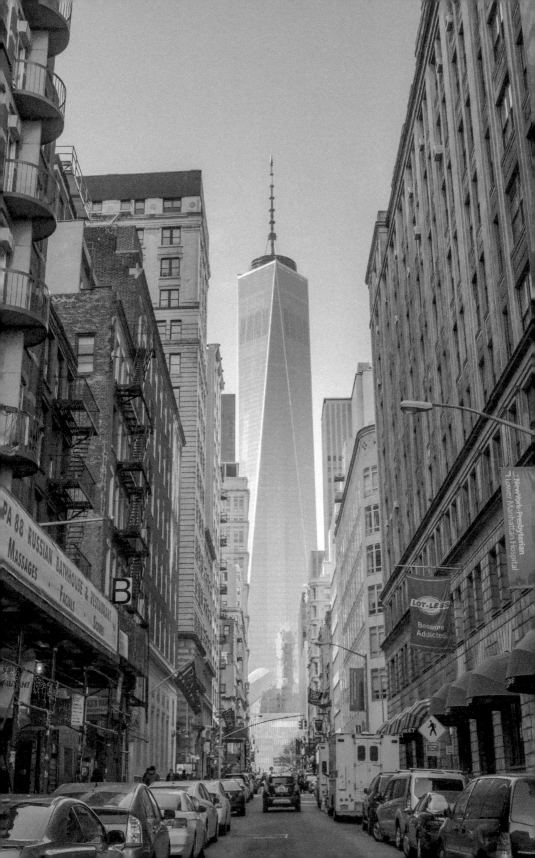

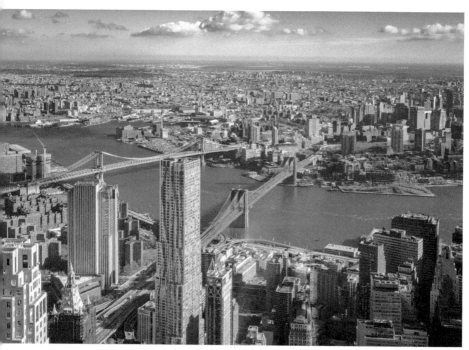

One World Observatory is the city's highest viewpoint. To the east, you can see the Brooklyn Bridge and the East River (above). To the north is the Empire State Building and Midtown Manhattan (below).

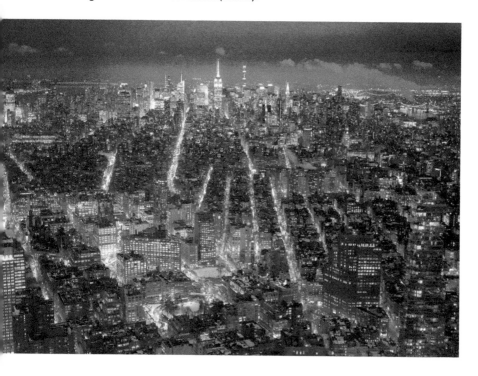

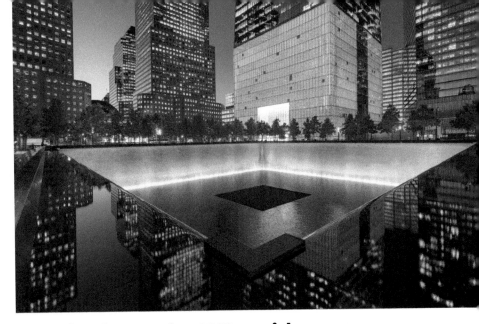

The **National September 11 Memorial** includes two square pools where the Twin Towers stood before the September 11 attacks of 2001. The corners of the North Pool (above) and South Pool (below) include views of One WTC. Between the pools is a park and a museum, with the remaining half of a fire truck from the fateful day.

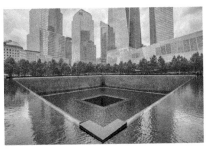
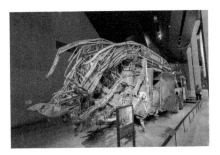

✉ **Addr:**	180 Greenwich St, New York NY 10006	♀ **Where:**	40.71064 -74.012942
❓ **What:**	Memorial	☾ **When:**	Morning
👁 **Look:**	North-northwest	W **Wik:**	National_September_11_Memorial_&_Museum

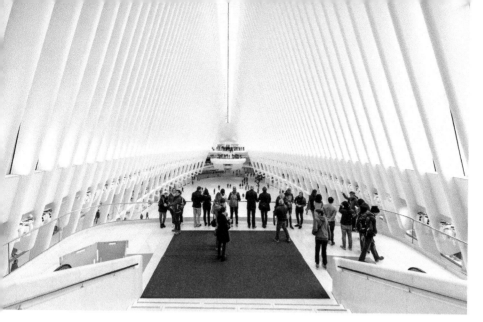

The **Oculus** opened in 2016 as the main station house of the World Trade Center Transportation Hub. Designed by Santiago Calatrava, the spectacular structure has white interlocking ribs that descend two floors below ground to house part of the Westfield World Trade Center mall.

The interior of the oval-shaped building can be photographed from ground-level decks on the west and east sides (above), and the floor (next page). Outside are interesting views from Fulton Street and Dey Street.

These shots benefit from a wide-angle lens, as the ribs almost envelope you. To get a clean white color (rather than a light gray), overexpose your shot by +⅔ or +1 EV (exposure value).

✉ **Addr:**	185 Greenwich St, New York NY 10007	♀ **Where:**	40.712165 -74.012087	
❓ **What:**	Building	◑ **When:**	Anytime	
👁 **Look:**	Southeast	W **Wik:**	World_Trade_Center_station_(PATH)	

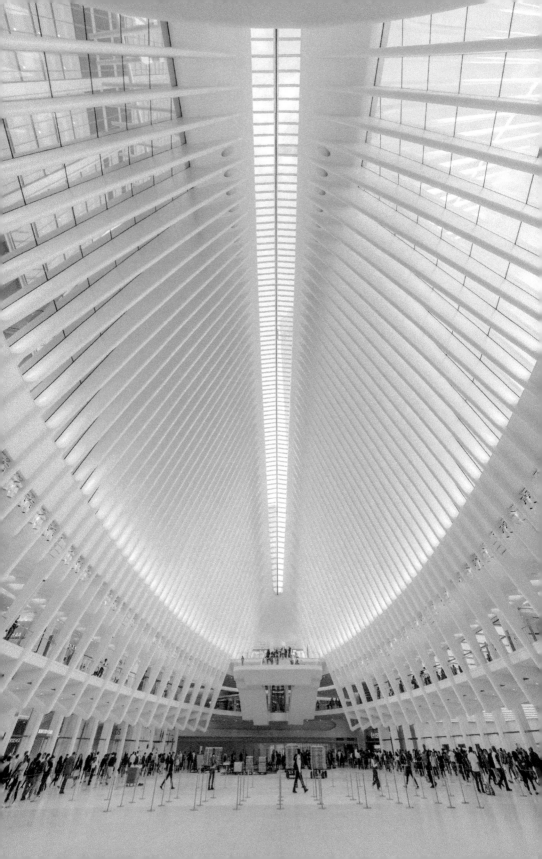

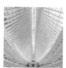
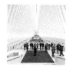

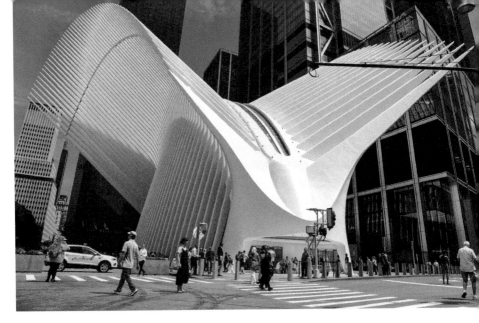

Above: The soaring wings from Fulton Street and Greenwich Street.

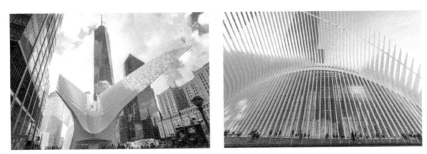

Above and below: From Fulton Street and Church Street you can include One WTC.

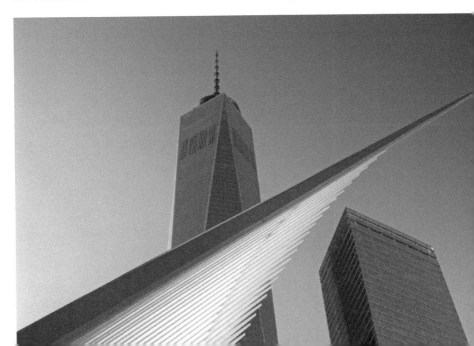

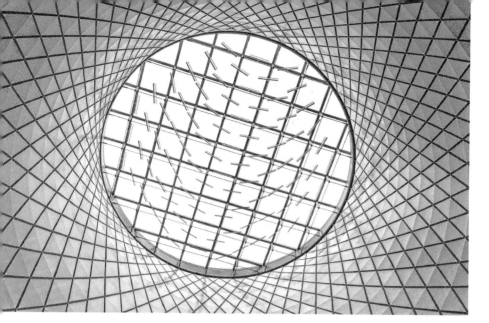

Fulton Center has a conical reflecting skylight called the Sky Reflector-Net. Below is a spaceship-like atrium which is an extension of the Westfield World Trade Center, a block to the west.

Fulton Center is a transit center and retail complex including the Fulton Building (pictured) and the landmark Corbin Building.

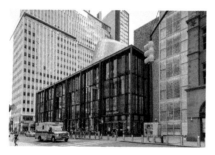
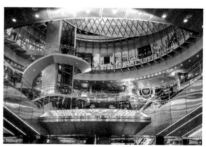

✉ **Addr:**	200 Broadway, New York NY 10038	♀ **Where:**	40.710497 -74.008962
❷ **What:**	Building complex	☽ **When:**	Afternoon
👁 **Look:**	South	W **Wik:**	Fulton_Center

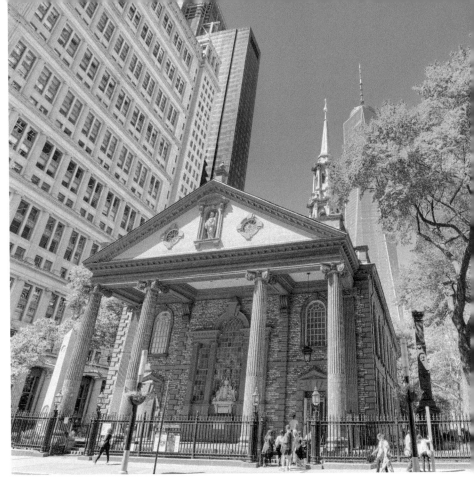

St. Paul's Chapel was built in 1766 and is the oldest surviving church building in Manhattan. "The Little Chapel That Stood" survived the 9/11 attacks 320 yards away (300 m) without even a broken window, and the fence hosted memorials to the fallen.

✉ **Addr:**	55 Church St, New York NY 10007	♀ **Where:**	40.711226 -74.008688
❷ **What:**	Church	◐ **When:**	Morning
👁 **Look:**	West	Ⓦ **Wik:**	St._Paul%27s_Chapel

 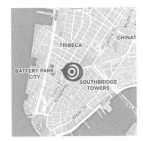 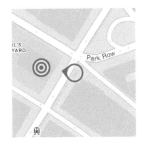

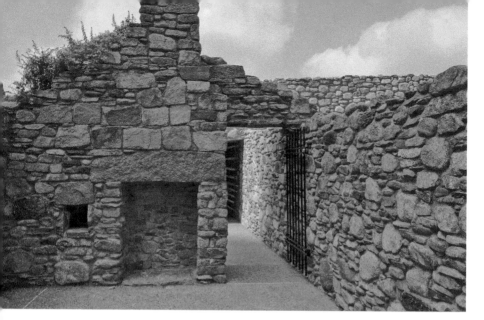

The **Irish Hunger Memorial** remembers the Great Irish Famine of 1845–52 in which over one million starved to death. Completed in 2002, the memorial includes an authentic Irish cottage from 19th century Carradoogan, a lined wall and tunnel, and a high ledge.

✉ **Addr:**	95 North End Ave, New York NY 10282	♀ **Where:**	40.715304 -74.016938
❓ **What:**	Memorial	☽ **When:**	Afternoon
👁 **Look:**	East-southeast	W **Wik:**	Irish_Hunger_Memorial

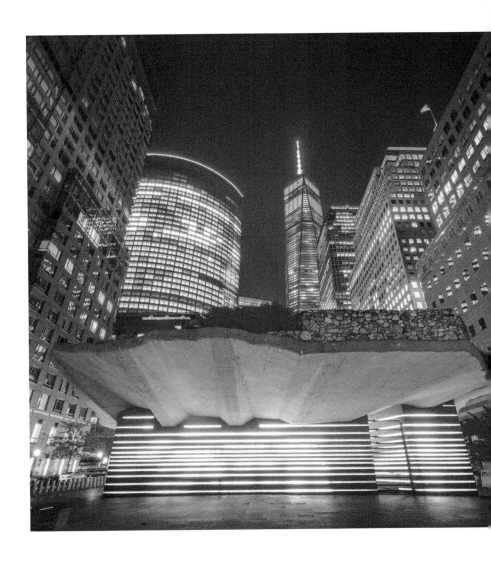

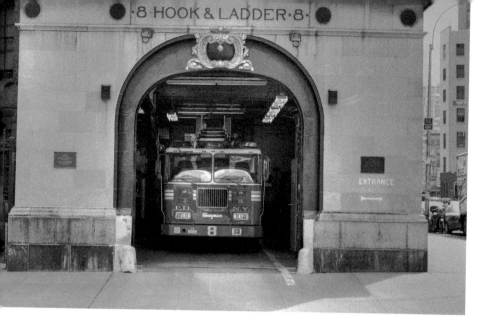

The **Ghostbusters Firehouse** is a real firehouse used as the home base of Dan Aykroyd and friends in the 1984 movie. The Beaux-Arts style Firehouse Hook & Ladder Company 8 was built in 1903.

You can photograph the Firehouse from Moore Street at Varick Street in Tribeca.

✉ **Addr:**	14 N Moore Street, New York NY 10013	♀ **Where:**	40.719781 -74.00657	
❷ **What:**	Firehouse	◑ **When:**	Morning	
👁 **Look:**	South	W **Wik:**	Firehouse,_Hook_%26_Ladder_Company_8	

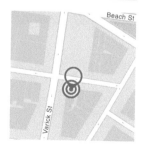

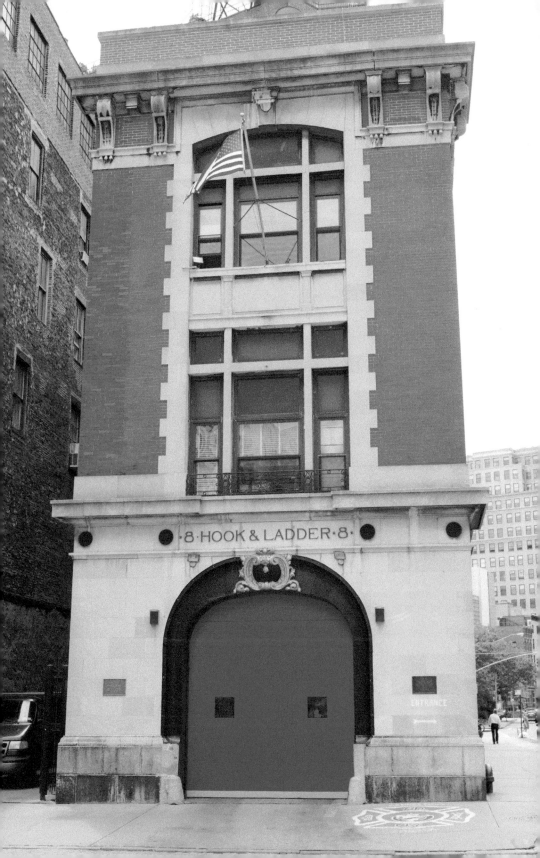

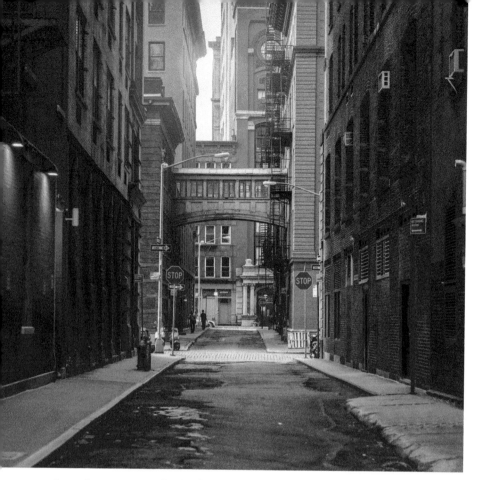

Staple Street Skybridge arches over a New York alley between brick buildings. Built in 1907 to connect two hospital buildings, the bridge is now part of a condominium. The above shot is from Duane Street; the following is from Harrison Street.

✉ **Addr:**	10 Staple Street, New York NY 10013	📍 **Where:**	40.717487 -74.009598
❓ **What:**	Skybridge	◑ **When:**	Afternoon
👁 **Look:**	North	↔ **Far:**	80 m (270 feet)

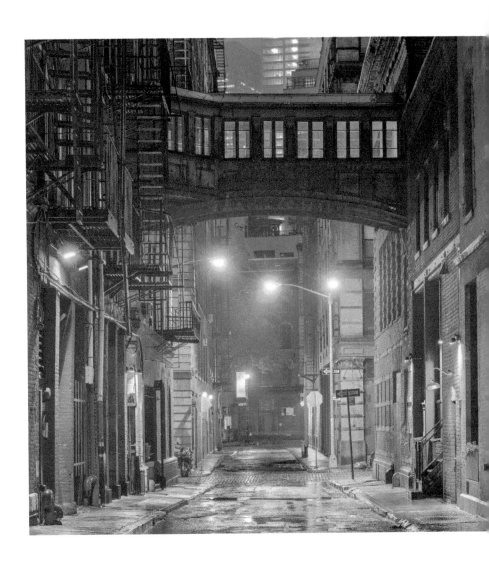

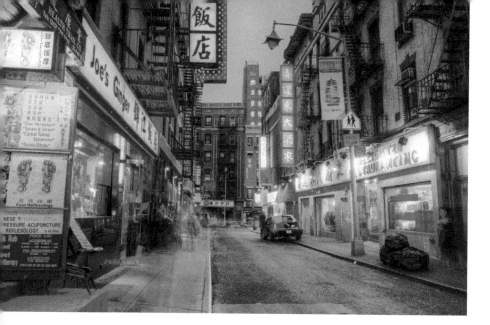

Chinatown is home to the highest concentration of Chinese people in the Western Hemisphere. The most atmospheric views are of Pell Street (from Doyers Street) and Mott Street, the unofficial "Main Street" of Chinatown.

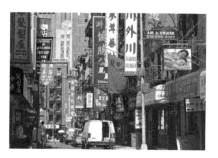

✉ **Addr:**	17 Pell St, New York NY 10013	📍 **Where:**	40.714818 -73.998083
🕐 **When:**	Morning	👁 **Look:**	West-northwest
W **Wik:**	Chinatown,_Manhattan		

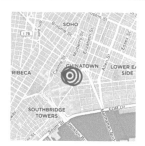
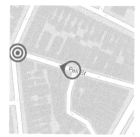

Eldridge Street Synagogue in

Chinatown has elaborate decoration under a 70-foot-high domed and barrel-vaulted ceiling.

Built in 1887 as one of the first synagogues erected in the United States by Eastern European Jews (Ashkenazim), the imposing Moorish Revival building was designed by the architects Peter and Francis William Herter.

This interior shot is from the Women's Balcony.

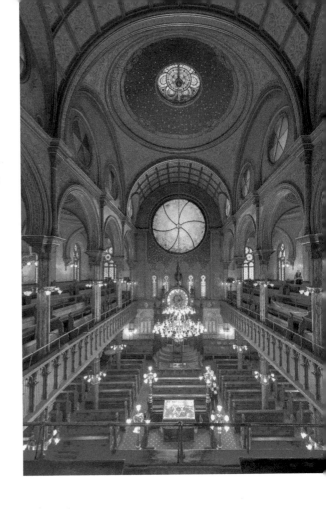

✉ **Addr:**	13a Eldridge St, New York NY 10002	📍 **Where:**	40.714757 -73.993568
When:	Afternoon	👁 **Look:**	East-southeast
W **Wik:**	Eldridge_Street_Synagogue		

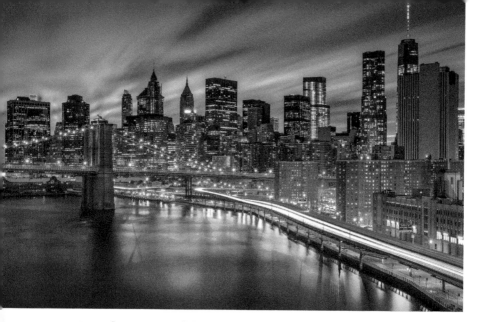

The **Manhattan Bridge Promenade** is a pedestrian path on the south side of Manhattan Bridge, with terrific views. The Manhattan entrance is from Bowery by Canal Street. The promendade is lined with a decorative fence (and chain-link fence) with just enough space for a lens to look through, or bring a tall monopod.

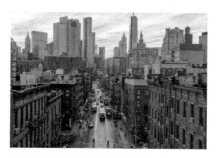
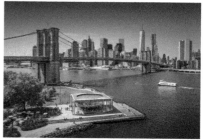

✉ **Addr:**	Manhattan Bridge, New York City NY 10002	♀ **Where:**	40.708737 -73.991528	
❓ **What:**	Pedestrian path	◑ **When:**	Morning	
👁 **Look:**	West	W **Wik:**	Manhattan_Bridge	

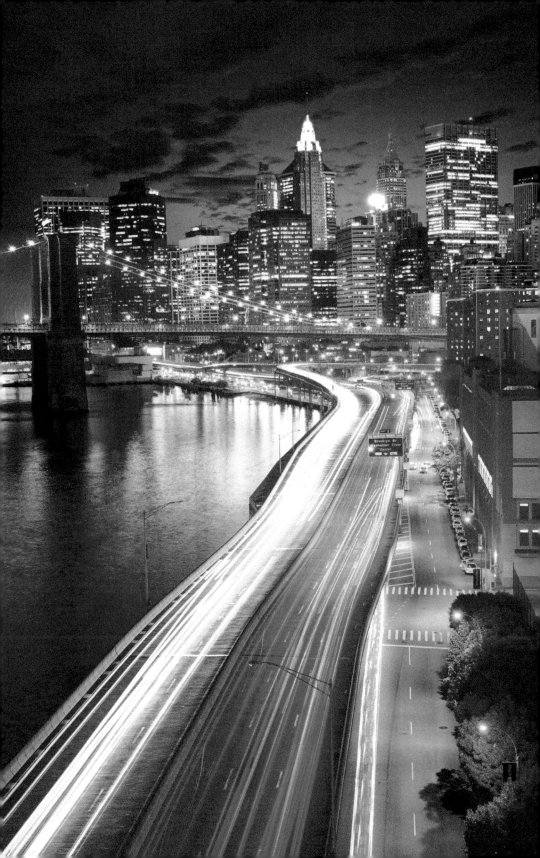

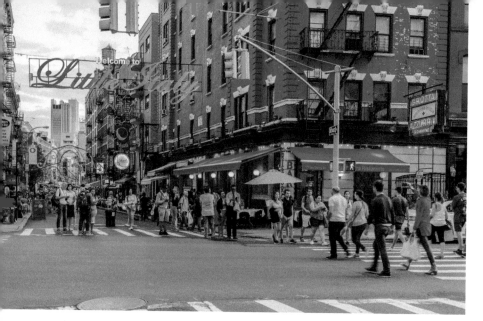

Little Italy was popular with Italian Americans in the 1880s. There is an illuminated sign above Mulberry Street at Broome Street and a building painted for the Italian flag at 189 Hester Street. The best time to photograph is in September, during the *Feast of San Gennaro*.

✉ **Addr:**	Mulberry at Hester, New York NY 10013	♀ **Where:**	40.720552 -73.996823
❓ **What:**	Neighborhood	◔ **When:**	Anytime
👁 **Look:**	South-southwest	Ⓦ **Wik:**	Little_Italy,_Manhattan

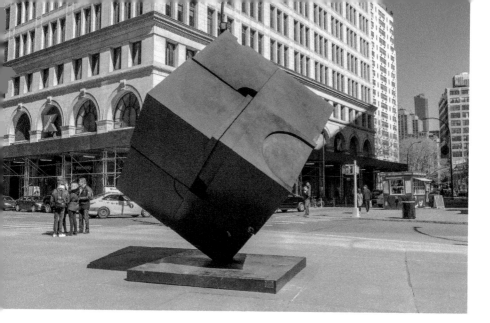

Alamo is a black cube in Astor Place. Designed by Bernard (Tony) Rosenthal in 1967, the 8 feet (2.4 m) long cube was named by his wife because its scale and mass reminded her of the Alamo Mission.

The cube can be rotated bys two or more people. Nearby is a reproduction of an old IRT kiosk.

✉ **Addr:**	57 Astor Place, New York NY 10003	♀ **Where:**	40.72985 -73.990928
❓ **What:**	Sculpture	☽ **When:**	Morning
👁 **Look:**	North-northwest	W **Wik:**	Alamo_(sculpture)

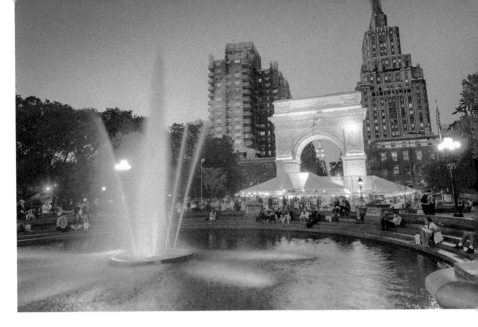

Washington Square in Greenwich Village is a star among New York's 1,900 public parks. A city landmark, its renowned features include the statuesque Washington Arch and a large fountain pool.

To get a romantic shot of the fountain, use a long exposure, such as ⅛s, which is easier to do at low-light dusk.

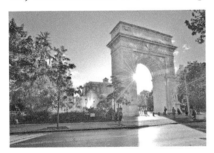

✉ **Addr:**	Washington Square, New York NY 10012	♀ **Where:**	40.730673 -73.997435
❓ **What:**	Park	☾ **When:**	Anytime
👁 **Look:**	North-northeast	W **Wik:**	Washington_Square_Park

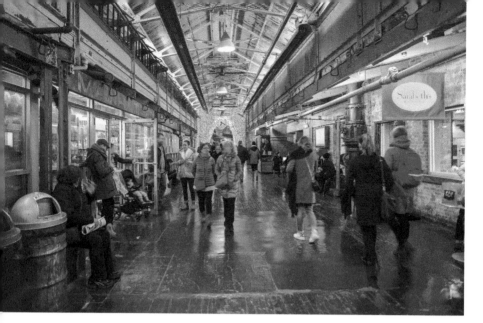

Chelsea Market is a block-long, block-wide, indoor food hall located in the Meatpacking District. Mere steps from the Hudson River, it lies within the Gansevoort Market Historic District. The High Line passes through the building on the Tenth Avenue side.

Inside is a brick archway and a well fountain.

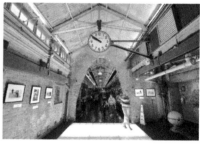

✉ **Addr:**	75 9th Ave, New York NY 10011	♀ **Where:**	40.742843 -74.006879	
❓ **What:**	Food hall	◑ **When:**	Afternoon	
👁 **Look:**	East-southeast	W **Wik:**	Chelsea_Market	

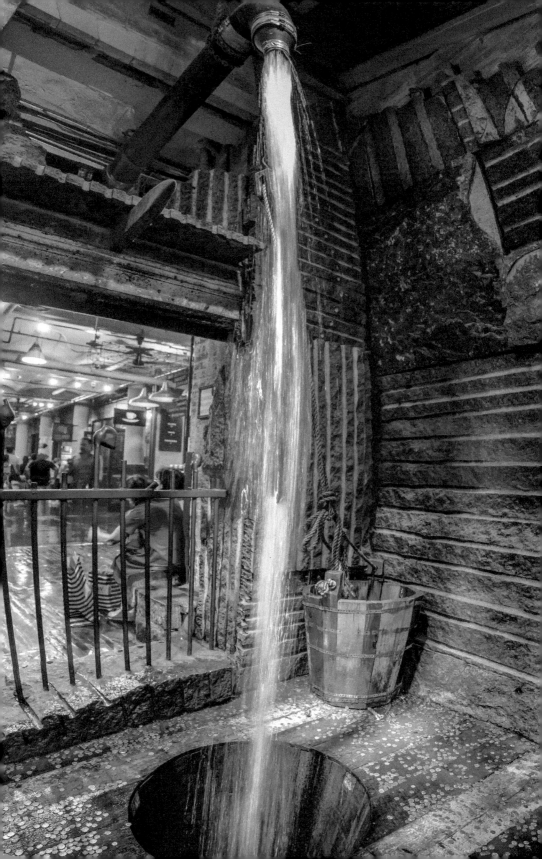

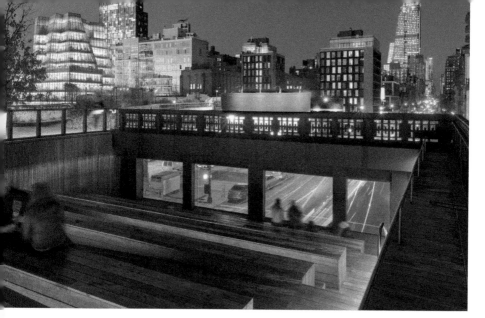

The **High Line** is a one-mile-long (1.6 km) elevated park on former railroad bridges, stretching from Gansevoort Street in the Meatpacking District (by the Whitney Museum of American Art) to 30th Street at Hudson Yards.

Along the way are views of the Standard Hotel (12th Street), the West 15th Street Skybridge (15th Street), Chelsea Market building (15th Street), Tenth Avenue Square (17th Street), the IAC Building (18th Street), the Empire State Building (20th Street) and the Zaha Hadid Building (28th Street).

✉ **Addr:**	210 10th Ave, New York NY 10011	♀ **Where:**	40.747333 -74.005133
❓ **What:**	Park	◑ **When:**	Afternoon
👁 **Look:**	North-northeast	W **Wik:**	High_Line_(New_York_City)

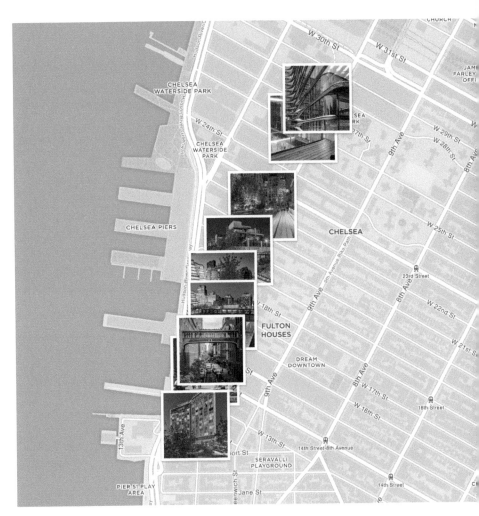

 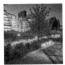

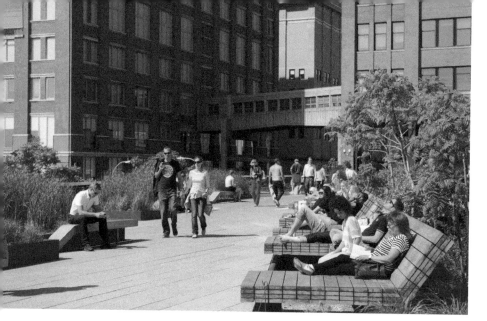

Above: Lounge chairs at W14th St. Below: Views from W18th and W20th streets.

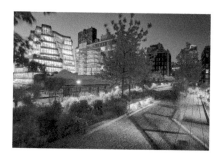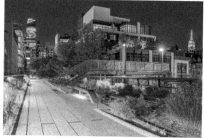

Below: The West 15th Street Skybridge by Chelsea Market, from the High Line.

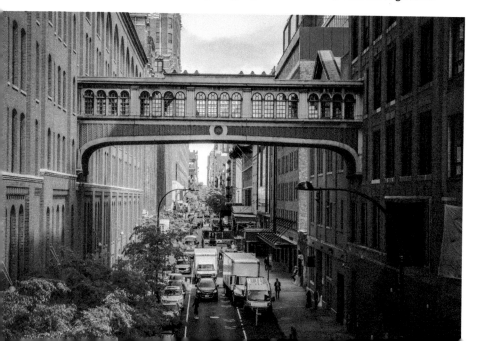

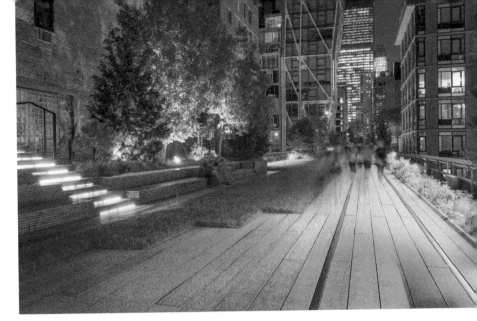

Above: West 22nd Street. Below: The West 26th Street scenic overlook.

Below: The Zaha Hadid Building as viewed from the High Line around W 28th Street.

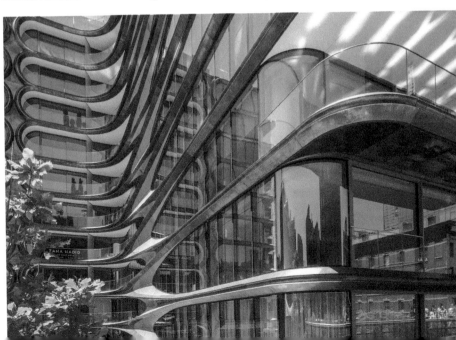

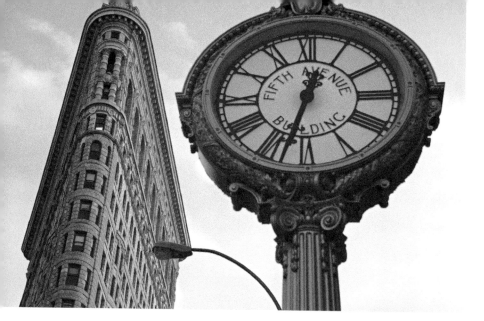

The **Flatiron Building** is a triangular skyscraper named for its resemblance to a cast-iron clothes iron. Completed in 1902 as one of the tallest buildings in the city, the now 22-story, 285-foot (87 m) high steel-framed landmark was designed by Chicago's Daniel Burnham as a vertical Renaissance palazzo with Beaux-Arts styling.

A good foreground is the nearby Fifth Avenue Building Clock, an ornate cast-iron sidewalk clock installed in 1909.

✉ **Addr:**	1 East 23rd Street, New York NY 10010	♀ **Where:**	40.742019 -73.989374
❷ **What:**	Building	◑ **When:**	Morning
👁 **Look:**	South	W **Wik:**	Flatiron_Building

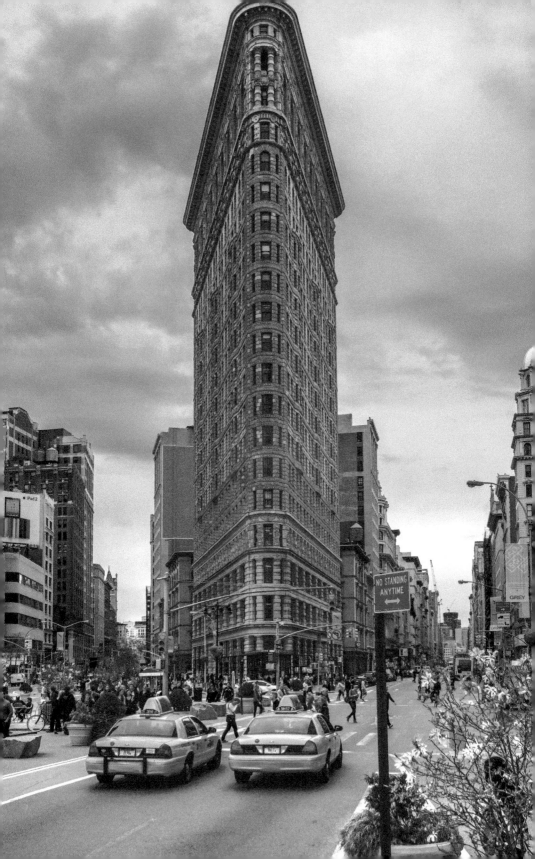

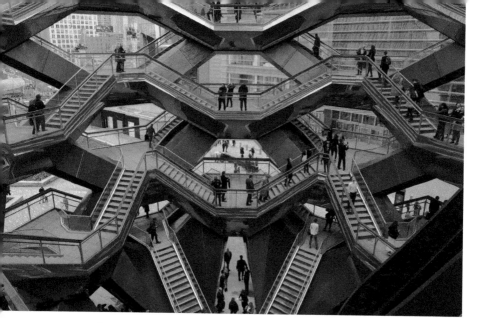

Vessel is an elaborate honeycomb-like artwork with interconnecting staircases. Inspired by Indian stepwells and created by British designer Thomas Heatherwick, *Vessel* has 154 flights of copper-clad stairs and 80 landings that stretch from its 50-foot-wide (15 m) base to its 150-foot-wide (46 m) apex.

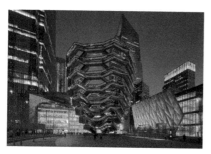

✉ **Addr:**	560 West 33rd Street, New York NY 10001	📍 **Where:**	40.753987 -74.002649
❓ **What:**	Structure	🕐 **When:**	Afternoon
👁 **Look:**	East-northeast	W **Wik:**	Vessel_(structure)

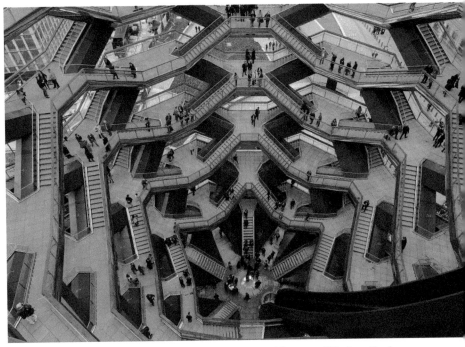

Likened to an M. C. Escher drawing, *Vessel* is the central feature of Hudson Yards, the country's largest private real estate development by square footage. Above: Looking down from the top. Below: Looking up from the base.

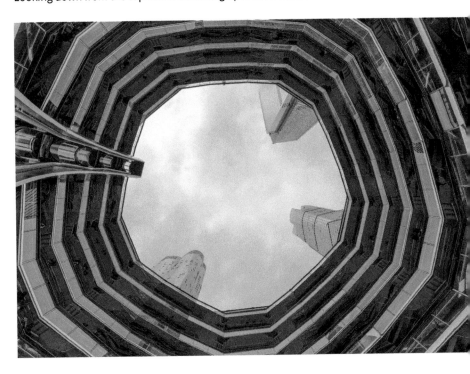

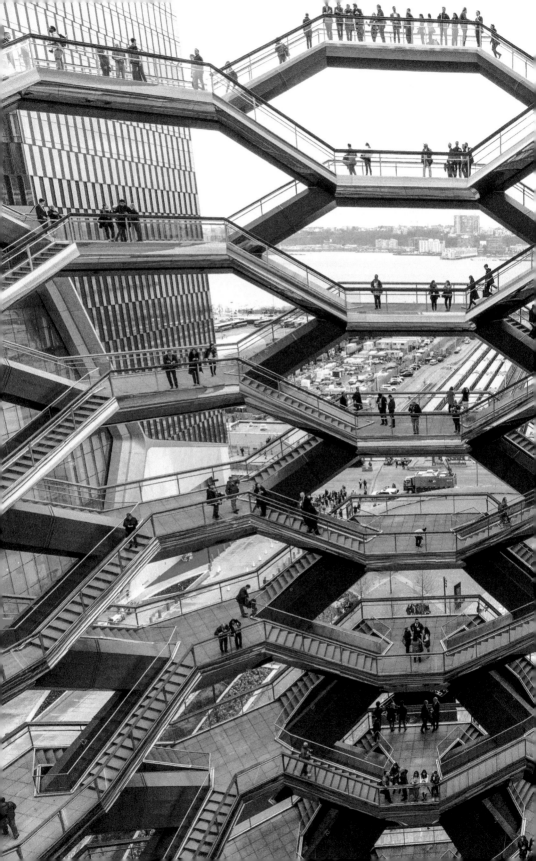

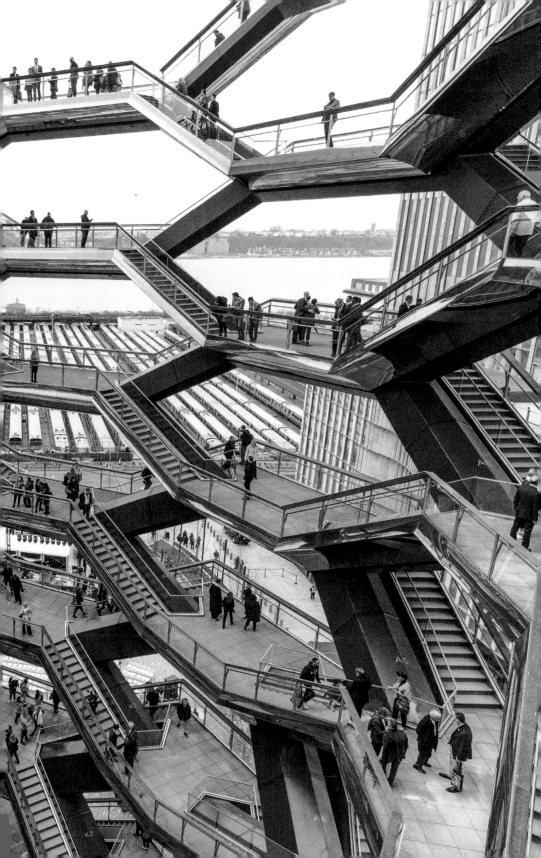

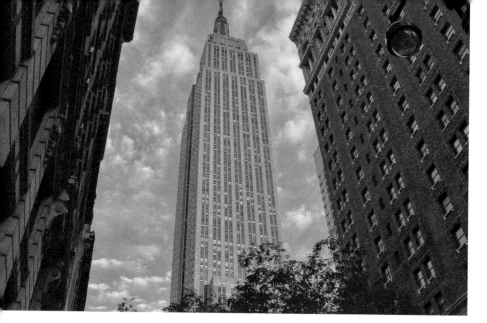

The **Empire State Building** is a 102-story Art Deco skyscraper and New York icon. Completed in 1931 as the the world's tallest building, this was the last refuge of King Kong in 1933.

Around four million people a year visit the building's 86th and 102nd floor observatories.

✉ **Addr:**	350 5th Avenue, New York NY 10118	📍 **Where:**	40.748433 -73.985656
❓ **What:**	Building	🕐 **When:**	Afternoon
👁 **Look:**	North	Ⓦ **Wik:**	Empire_State_Building

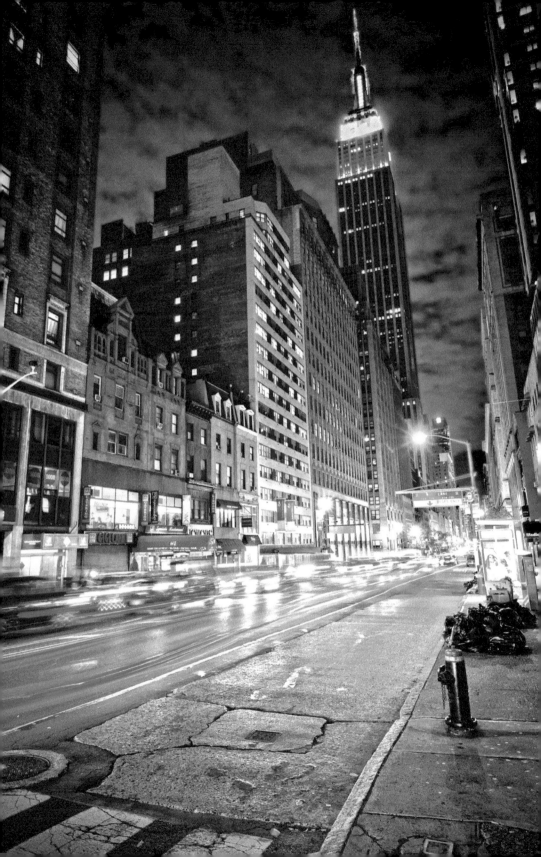

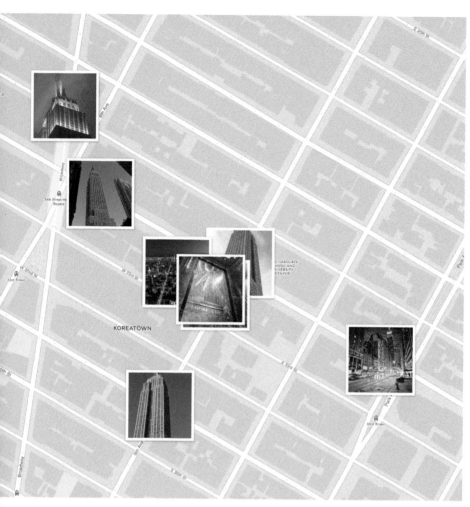

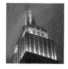

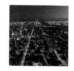
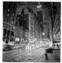

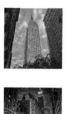

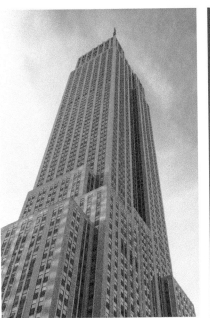
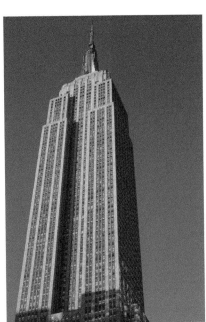
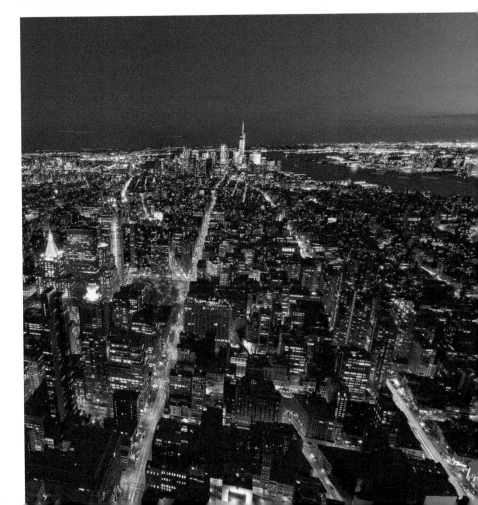

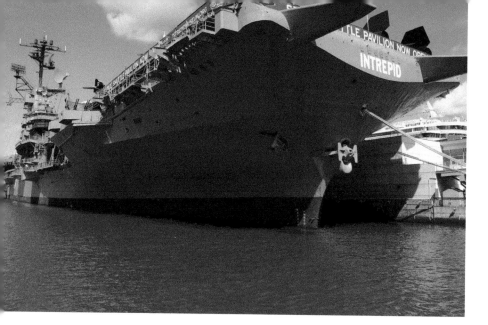

USS Intrepid is a WWII aircraft carrier now used as a museum. Other exhibits include the cruise missile submarine USS Growler, a British Airways Concorde, a Lockheed A-12 supersonic reconnaissance plane, and the Space Shuttle Enterprise (inside a pavilion).

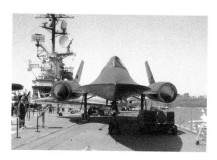

✉ **Addr:**	Pier 86 W 46th St and 12th Ave, New York NY 10036	♀ **Where:**	40.7638678 -73.9993696
❓ **What:**	Museum	⏱ **When:**	Morning
👁 **Look:**	Northwest	W **Wik:**	Intrepid_Sea,_Air_&_Space_Museum

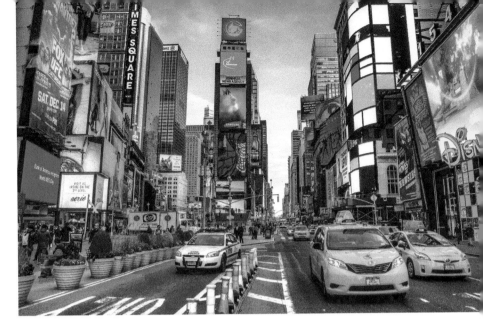

Times Square at the intersection of Broadway and Seventh Avenue is the hub of the Broadway Theater District. In the center of this photo, taken from W 45th Street, is the former home of *The New York Times* (which named the square) and, since 1907, is the site of the annual New Year's Eve ball drop.

✉ **Addr:**	Seventh Ave (45th-47th), Manhattan NY 10036	♀ **Where:**	40.758018 -73.985517
⏲ **When:**	Afternoon	👁 **Look:**	North-northeast
W **Wik:**	Times_Square		

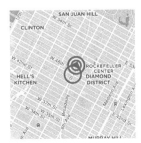

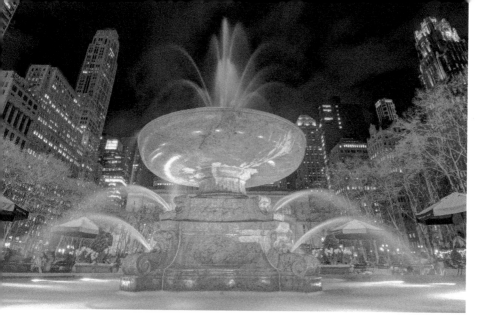

Bryant Park is the largest lawn south of Central Park and is built entirely over the underground stacks of the adjacent New York Public Library. On the west side, is the Josephine Shaw Lowell Memorial Fountain (above), good for a dusk shot. The lawn extends east to the nature-covered Bryant Park Grill.

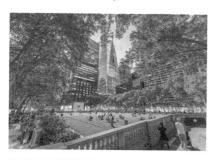

✉ **Addr:**	41 W 40th St, New York NY 10018	♀ **Where:**	40.75406 -73.984326
❓ What:	Park	**◑ When:**	Afternoon
👁 Look:	East-southeast	**W Wik:**	Bryant_Park

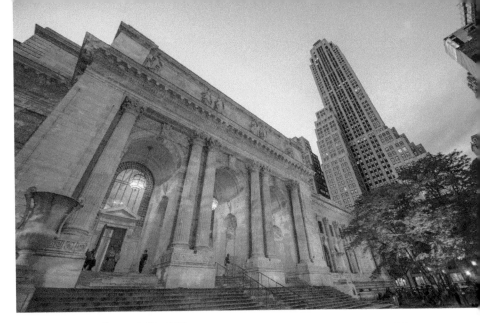

The **New York Public Library** is a landmark Beaux-Arts marble structure opened in 1911. The magnificent interior includes the Wallace Periodical Room (bottom left), the McGraw Rotunda (bottom right) (both on the third floor), and the enormous Rose Main Reading Room (next page).

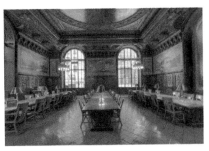
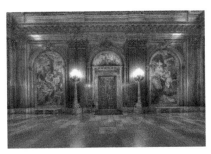

✉ **Addr:**	476 5th Avenue, New York NY 10018	♀ **Where:**	40.7527123 -73.9814807
❓ **What:**	Library	☾ **When:**	Afternoon
👁 **Look:**	North	W **Wik:**	New_York_Public_Library_Main_Branch

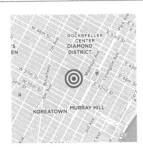

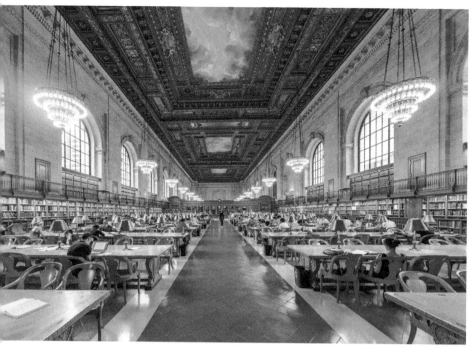

The Rose Main Reading Room is 78 by 297 feet (24 by 91 m) with a 52-foot-high ceiling, nearly as large as the Main Concourse of Grand Central Terminal, which was designed to complement the Library.

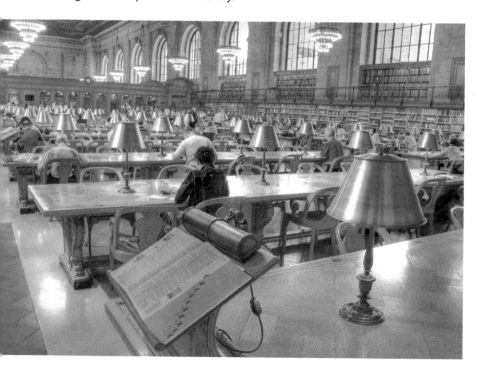

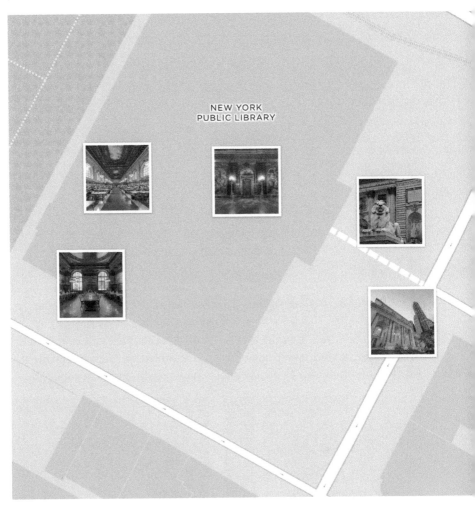

NEW YORK
PUBLIC LIBRARY

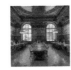

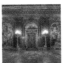

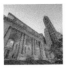

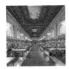

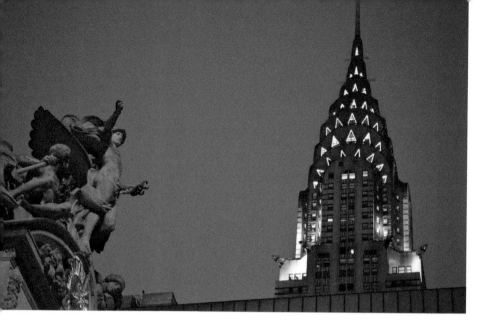

The **Chrysler Building** has a distinctive Art Deco stainless steel crown and spire, like a vertical swordfish. Headquarters for the car manufacturer until the mid-1950s, the design includes hubcaps, hood ornaments and fenders. Good views are from Grand Central Terminal (above) and the Hyatt Centric Times Square rooftop bar (next page).

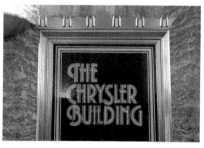

✉ **Addr:**	405 Lexington Avenue, New York NY 10174	♀ **Where:**	40.752301 -73.977832
❷ **What:**	Building	☾ **When:**	Afternoon
👁 **Look:**	East-southeast	W **Wik:**	Chrysler_Building

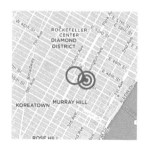

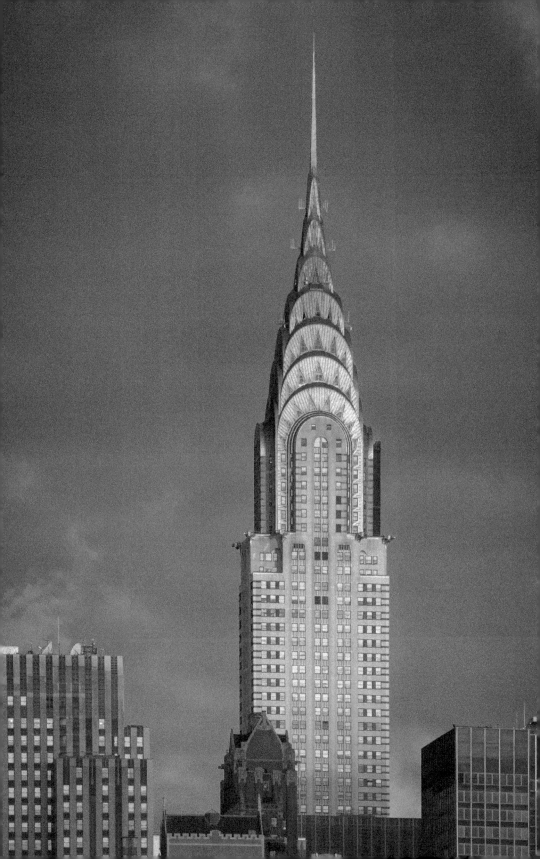

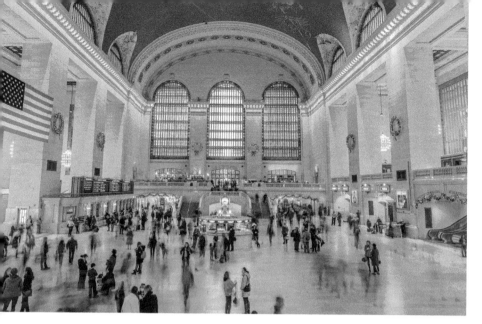

Grand Central Terminal is the largest train station in the world
by number of platforms, all 44 of which are below ground. Opened in
1913, the Beaux-Arts building by Reed and Stem includes the 125-feet
(38 m) high Main Concourse with a four-faced brass clock, and an eagle
on the west corner.

 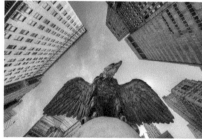

✉ **Addr:**	89 E 42nd Street, New York NY 10017	♀ **Where:**	40.7528 -73.976522
❷ **What:**	Railroad station	☾ **When:**	Afternoon
👁 **Look:**	North	W **Wik:**	Grand_Central_Terminal

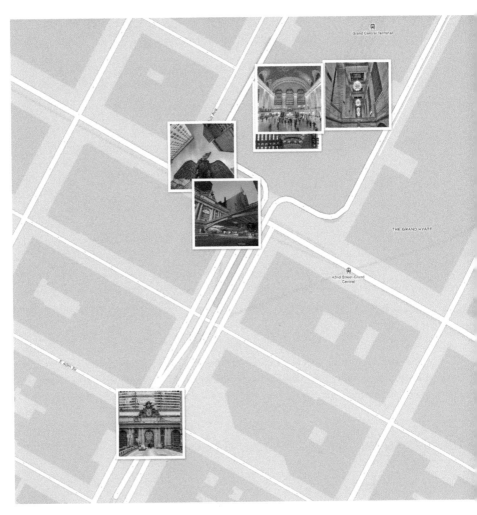

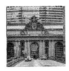

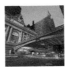

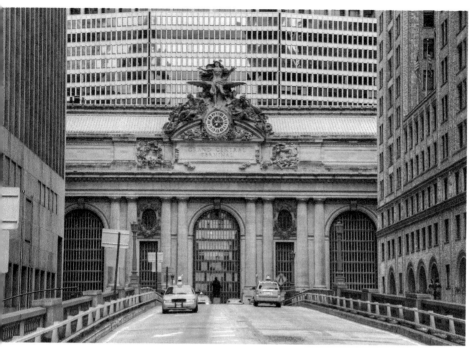

The Park Avenue Viaduct is an elevated road that goes around the terminal building. *The Avengers* and *I Am Legend* were filmed here. From below at 42nd Street, you can capture the *Glory of Commerce* sculptural group and the Chrysler Building.

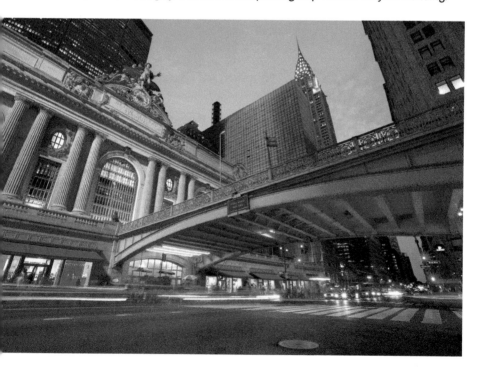

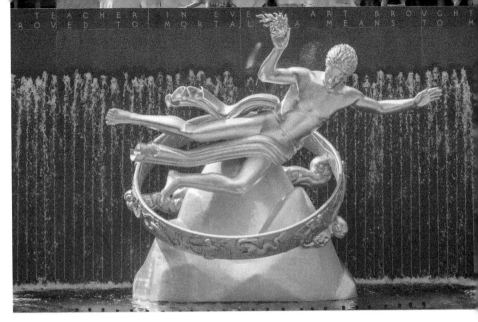

Rockefeller Center is a 22-acre complex with 14 Art Deco buildings commissioned by the Rockefeller family. In the middle, overseen by a golden statue of *Prometheus* (above) by Paul Manship, is a large sunken square called Rockefeller Plaza (right), which is converted to an ice-skating rink in the winter.

The main building is the 66-story high 30 Rockefeller Plaza (known as 30 Rock), home to the New York studios and headquarters of television network NBC. *The Tonight Show* and *Saturday Night Live* are filmed here. Over the east entrance is the Wisdom frieze (pictured later) by German artist Lee Lawrie, whose most noted work is the nearby statue of *Atlas*.

✉ **Addr:**	45 Rockefeller Plaza, New York NY 10111	♀ **Where:**	40.75861 -73.97917
❓ **What:**	Neighborhood	◑ **When:**	Anytime
👁 **Look:**	North	W **Wik:**	Rockefeller_Center

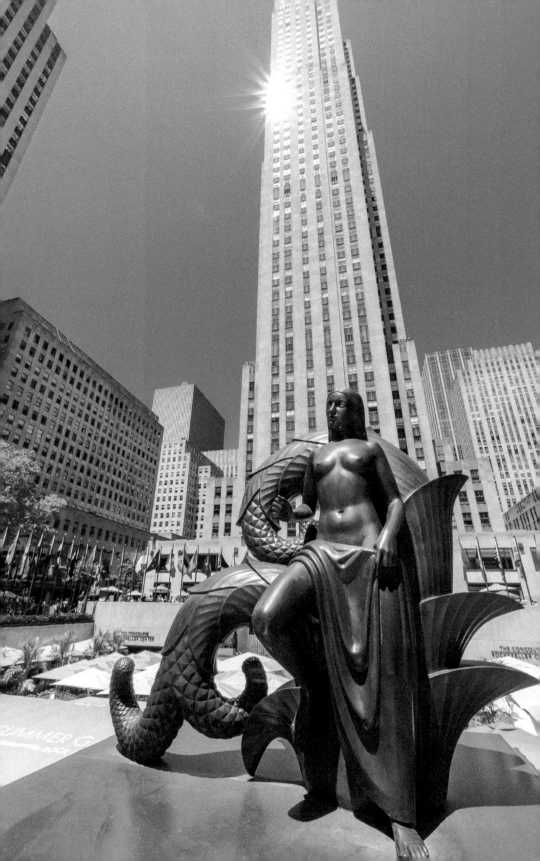

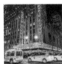

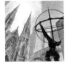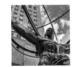

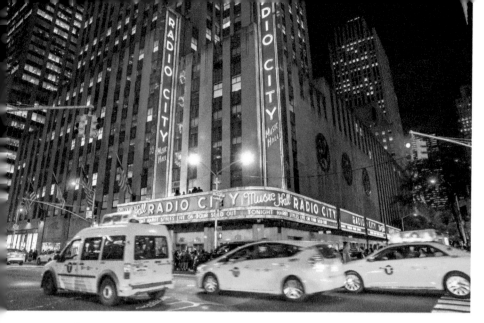

Radio City Music Hall is part of the Rockefeller Center, at Sixth Ave and W50th Street.

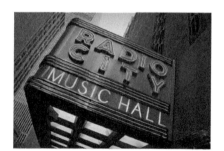 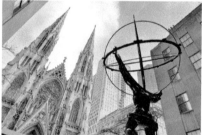

Atlas depicts the Ancient Greek Titan holding up the celestial heavens.

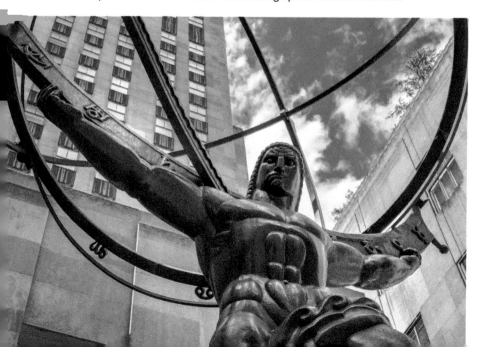

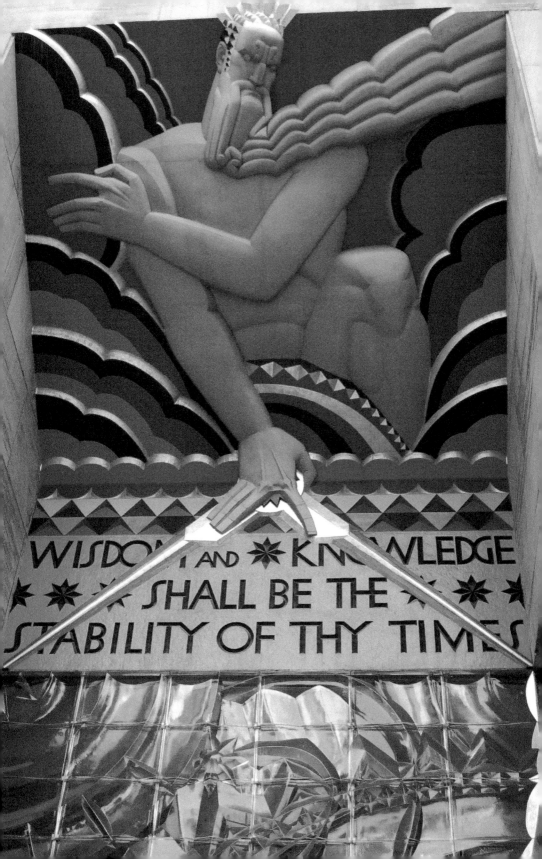

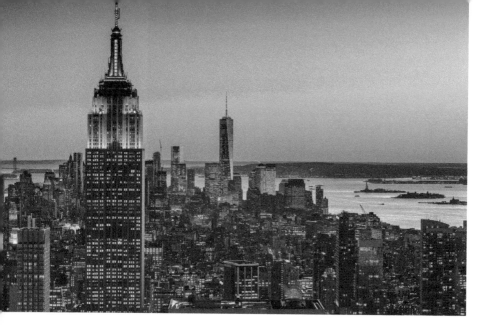

Top of the Rock offers the best observation deck views in New York.

 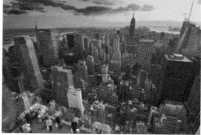

Looking south to the Empire State Building, and north to Central Park.

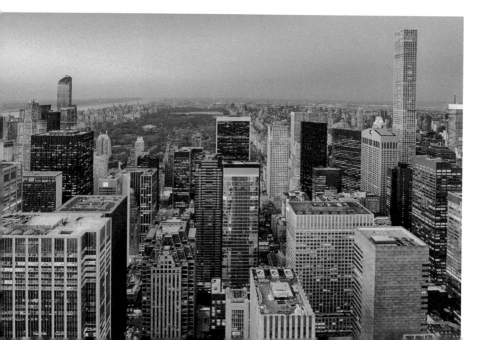

Saint Patrick's Cathedral is the largest decorated Neo-Gothic-style Catholic cathedral in North America. Designed by James Renwick Jr. and built 1858–79, the cathedral can accommodate 3,000 people under towering vaulted ceilings.

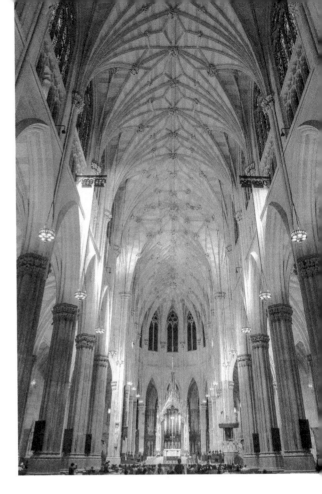

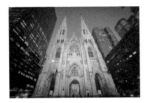

✉ **Addr:**	460 Madison Avenue, New York NY 10022	♀ **Where:**	40.758904 -73.977135
❷ **What:**	Cathedral	◑ **When:**	Anytime
◉ **Look:**	East-southeast	W **Wik:**	St._Patrick%27s_Cathedral_(Manhattan)

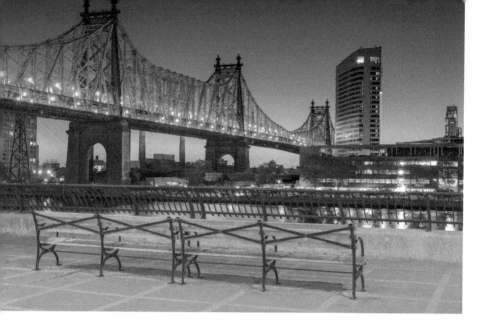

Sutton Place at Riverside Terrace has a view of the Queensboro Bridge used in Woody Allen's 1979 movie *Manhattan*.

The movie used the view from the end of E 59th Street but there is not a bench there (it was a prop). This bench is on a deck at the end of Sutton Square.

✉ **Addr:**	1 Riverview Terrace, New York NY 10022	📍 **Where:**	40.757691 -73.959355
🕐 **When:**	Anytime	👁 **Look:**	East-southeast
W **Wik:**	Manhattan_(film)		

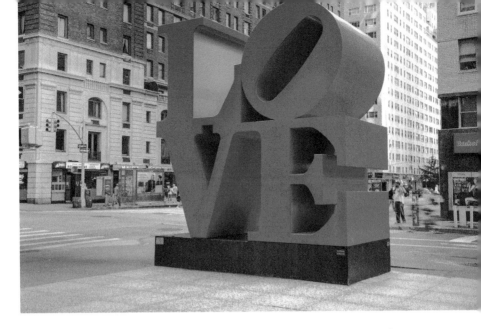

Love is a pop art sculpture at Sixth Avenue and W 55th Street. The original image by Robert Indiana was first used in 1964 by the Museum of Modern Art, one block south.

✉ **Addr:**	96 W 55th St, New York NY 10019	♀ **Where:**	40.762812 -73.978021	
❷ **What:**	Sculpture	◑ **When:**	Morning	
👁 **Look:**	North	W **Wik:**	Love_(sculpture)	

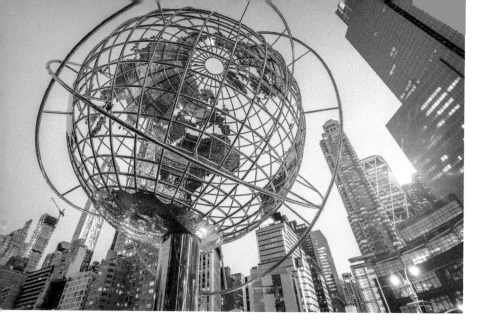

Globe is a 30-foot-wide (9 m) steel sculpture by Kim Brandell. Based on the Unisphere in Queens (pictured later), the globe stands at Columbus Circle, and is a good foreground for surrounding skyscrapers such as Time Warner Center.

✉ **Addr:**	1 Central Park West, New York NY 10023	♀ **Where:**	40.768833 -73.981665
❓ **What:**	Sculpture	◑ **When:**	Morning
👁 **Look:**	Southwest	W **Wik:**	Columbus_Circle

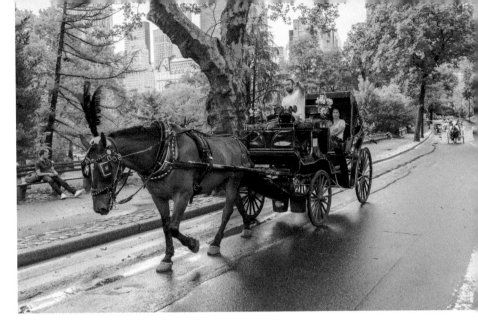

Central Park is the country's most visited urban park and one of the world's most filmed locations. Founded in 1853, the park was designed by Frederick Law Olmsted and Calvert Vaux in 1857.

You can capture that bygone era with photos of **horse-drawn carriages**, which can be rented along 59th Street at Seventh Avenue.

✉ **Addr:**	W 59th St, New York NY 10019	♀ **Where:**	40.766909 -73.979013
❓ **What:**	Horse-drawn carriage	◑ **When:**	Afternoon
👁 **Look:**	Northeast	W **Wik:**	Central_Park

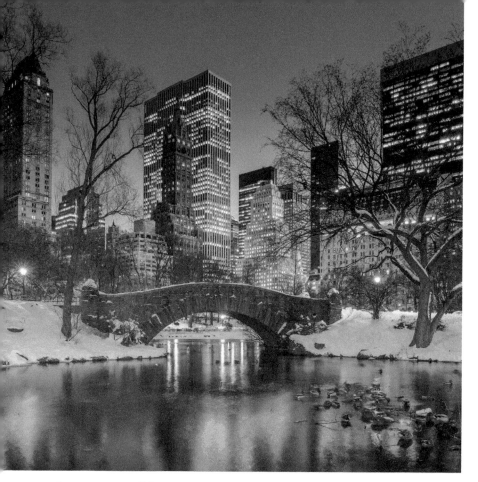

Gapstow Bridge graces the southeast corner of Central Park. Built in 1896 from Manhattan schist, the fieldstone arch crosses the Pond, with views of the Plaza Hotel behind.

✉ **Addr:**	14 E 60th St, New York NY 10022	♀ **Where:**	40.767242 -73.973907	
❓ **What:**	Bridge	☾ **When:**	Afternoon	
👁 **Look:**	South-southeast	W **Wik:**	The_Pond_and_Hallett_Nature_Sanctuary	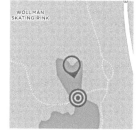

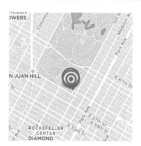

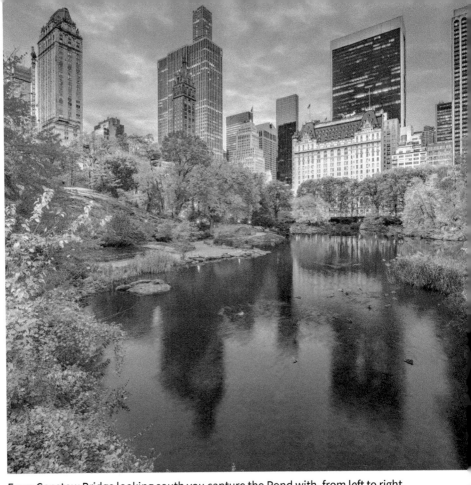

From Gapstow Bridge looking south you capture the Pond with, from left to right, The Pierre hotel, the Sherry-Netherland apartment hotel, the General Motors Building, the Plaza Hotel and the Solow Building.

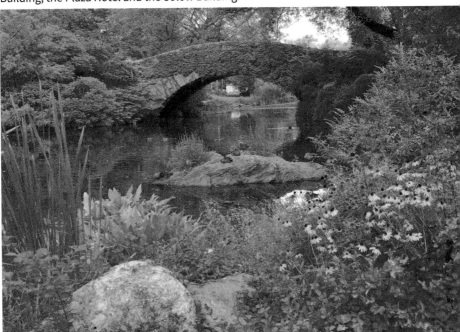

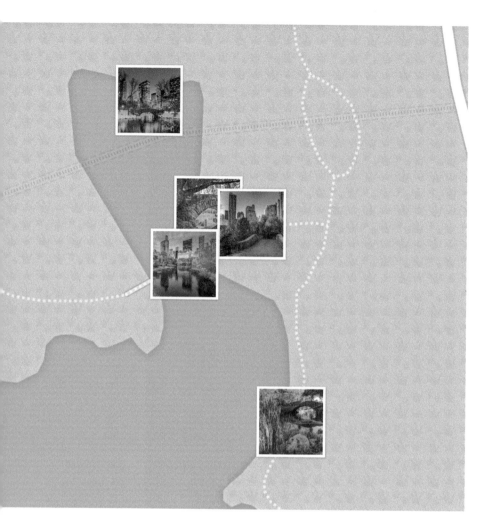

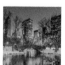 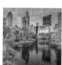

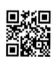

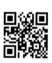

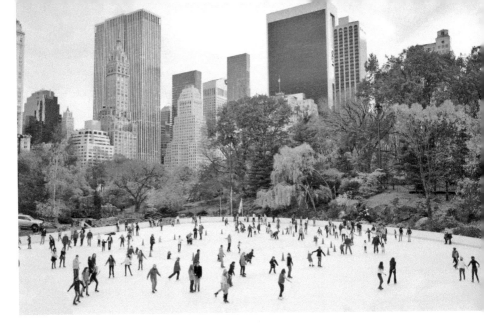

Wollman Rink is a public ice rink just north of Gapstow Bridge. The rink is open for ice skating from late October to early April; from late May to September it is transformed into Victoria Gardens, an amusement park for children.

The rink was opened in 1949 with funds donated by Kate Wollman.

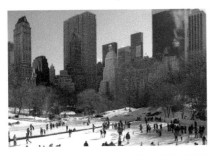

✉ **Addr:**	E 63rd Street, New York NY 10019	♀ **Where:**	40.7682268 -73.9745867
❷ **What:**	Skating rink	◑ **When:**	Afternoon
👁 **Look:**	South	W **Wik:**	Wollman_Rink

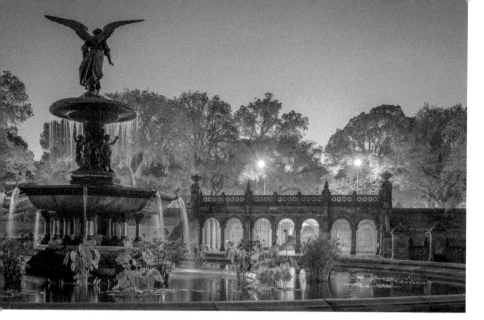

Bethesda Terrace and Fountain is a romantic area between
The Mall and The Lake. In the center of the terrace is the fountain, topped with the *Angel of the Waters* statue by Emma Stebbins, the first major work of art by a woman in New York City. Facing the terrace is an arcade, a pedestrian path under a bridge for Terrace Drive.

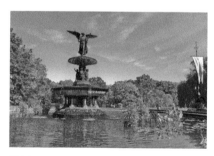

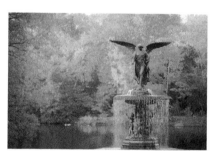

✉ **Addr:**	E 72nd Street, New York NY 10019	📍 **Where:**	40.7744741 -73.9708707	
❓ **What:**	Fountain	🕐 **When:**	Afternoon	
👁 **Look:**	South	W **Wik:**	Bethesda_Terrace_and_Fountain	

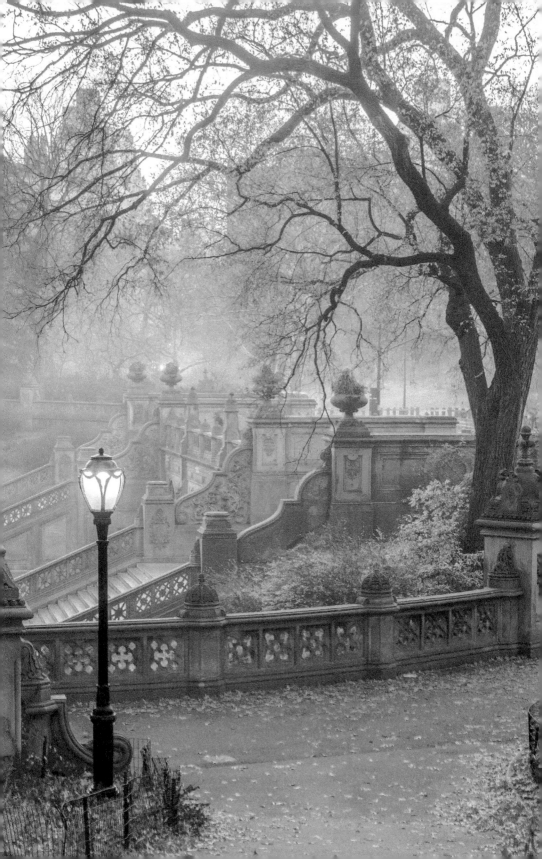

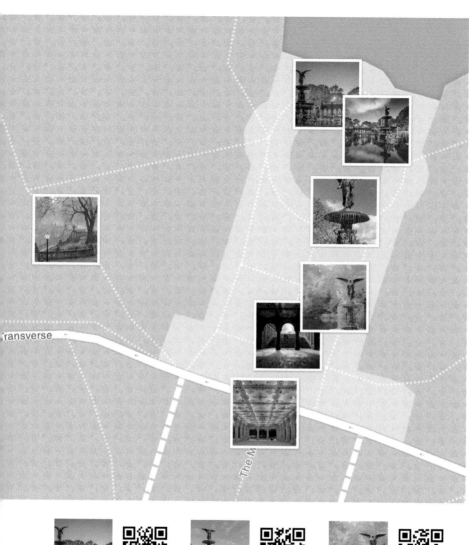

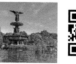

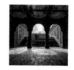

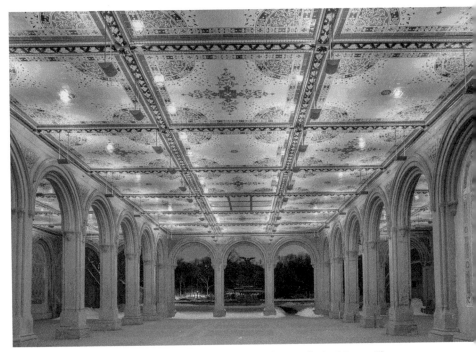

Between the stairs of Bethesda Terrace is an arcade, known for its Minton tile ceiling. You can photograph the arcade from the south looking to the fountain (above), and from the north toward steps from The Mall (below).

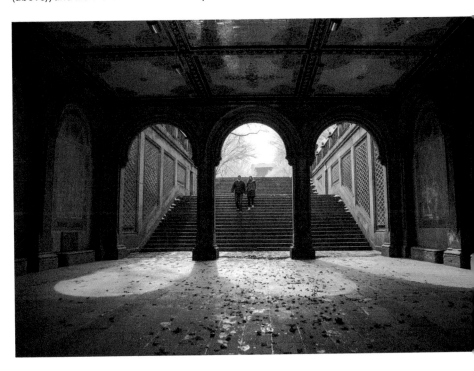

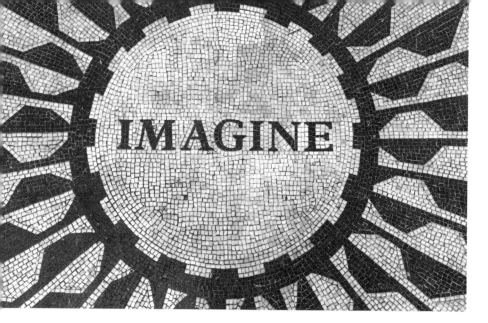

Strawberry Fields is a 2.5-acre landscaped area with a circular mosaic titled "Imagine." The area is dedicated to former Beatle, John Lennon, who wrote the songs *Strawberry Fields Forever* and *Imagine*. He was murdered about 330 feet (100 m) west of here in 1980, outside his home at The Dakota apartment building on 72nd Street.

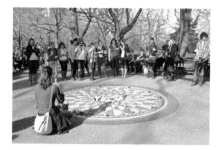

✉ **Addr:**	W 72nd St, New York NY 10019	♀ **Where:**	40.775725 -73.975296
❓ **What:**	Memorial	☾ **When:**	Afternoon
👁 **Look:**	South-southeast	W **Wik:**	Strawberry_Fields_(memorial)

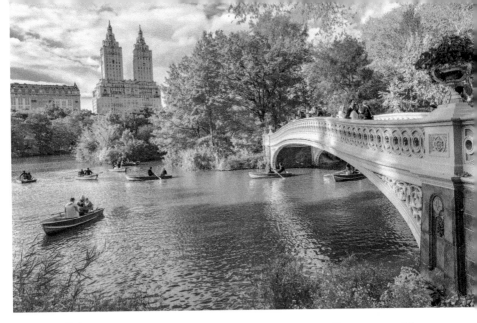

Bow Bridge is the longest bridge in Central Park. Built 1859–62, this is the second oldest cast-iron bridge in America.

Named for its graceful curve, which is like the bow of an archer or violinist, Bow Bridge features balustrades interlaced circles around Gothic cinquefoils. Like many structures in the park, the arch was designed by two British architects, Calvert Vaux and Jacob Wrey Mould.

Bow Bridge spans the lake by Bethesda Terrace, and points toward The San Remo, a twin-towered apartment building home to many famous people including Steven Spielberg, Steve Martin, Barry Manilow, Glenn Close, Dustin Hoffman and Diane Keaton.

✉ **Addr:**	E 74th Street, New York NY 10024	♀ **Where:**	40.775626 -73.971787
❓ **What:**	Bridge	☽ **When:**	Afternoon
👁 **Look:**	North	W **Wik:**	Bow_Bridge,_Central_Park

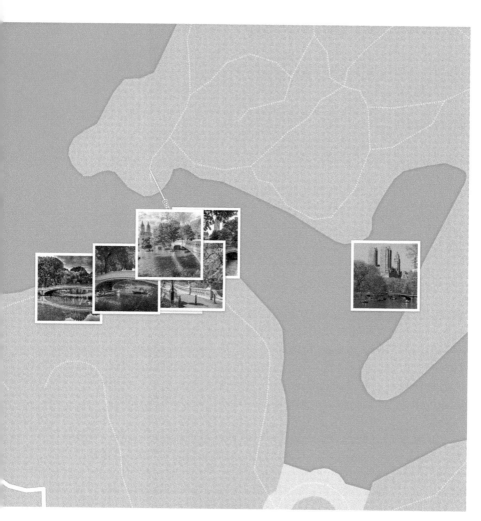

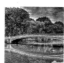

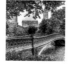

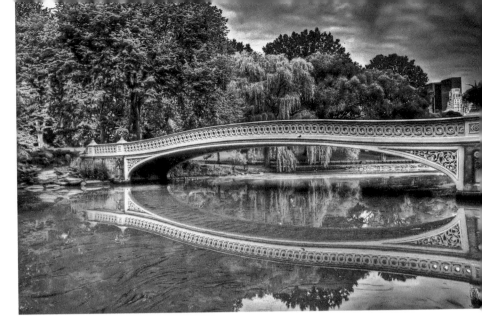

Southwest of the bridge is a small area to take this shot.

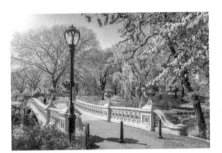

Views from southeast and east of Bow Bridge.

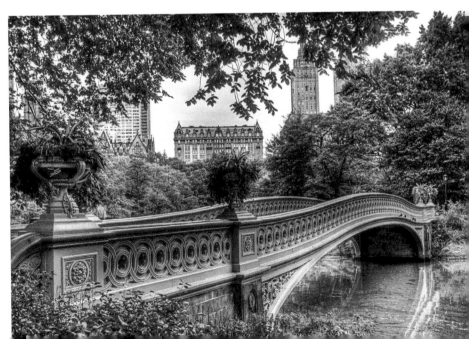

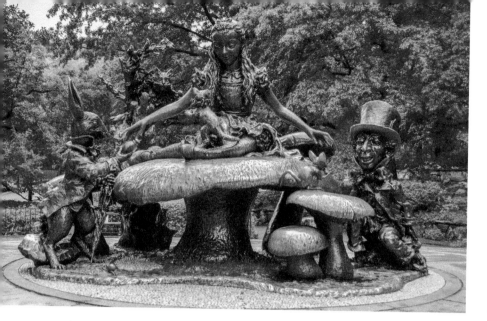

Alice in Wonderland sits on a mushroom with the Mad Hatter, the White Rabbit and a timid dormouse in this 1959 sculpture by José de Creeft. Philanthropist George Delacorte commissioned the bronze work as a tribute to his wife, Margarita, who read to their children the Lewis Carroll classic, *Alice's Adventures in Wonderland*.

✉ **Addr:**	E 75th St, New York NY 10021	♥ **Where:**	40.7749873 -73.9666065
❓ **What:**	Statue	☼ **When:**	Afternoon
👁 **Look:**	Northeast	W **Wik:**	List_of_sculptures_in_Central_Park#Fictional_characters

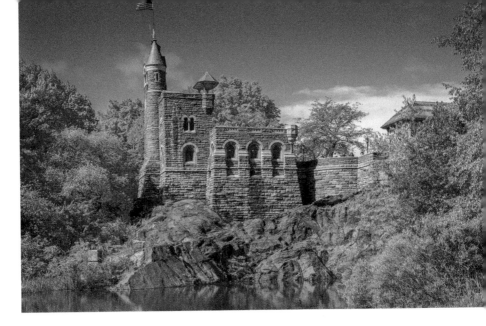

Belvedere Castle looks like a mini Hogwarts. This Victorian folly was designed by Frederick Law Olmsted and Calvert Vaux in Gothic and Romanesque styles and looks out over the Turtle Pond. Belvedere means "beautiful view" in Italian.

✉ **Addr:**	W 79th Street, New York NY 10024	♀ **Where:**	40.779926 -73.968172
❓ **What:**	Castle	☾ **When:**	Morning
👁 **Look:**	Southwest	W **Wik:**	Belvedere_Castle

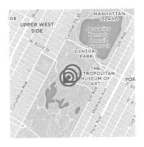
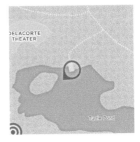

The **Shakespeare Garden** is located near Belvedere Castle and the Delacorte Theater, home to the New York Shakespeare Festival. The garden contains flowers and plants mentioned in the Bard's plays. Nearby, is the Swedish Cottage Marionette Theatre, imported from Sweden in 1876.

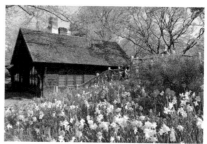

✉ **Addr:**	W 79th Street, New York NY 10024	📍 **Where:**	40.779533 -73.969952	
❓ **What:**	Garden	◑ **When:**	Morning	
👁 **Look:**	North	W **Wik:**	Shakespeare_garden#Central_Park	

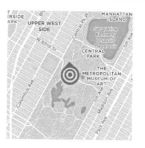
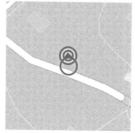

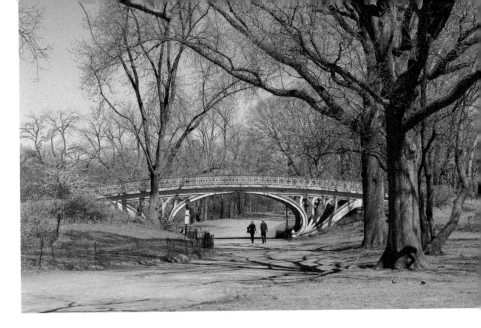

Gothic Bridge is colloquially named for the Gothic Cathedral-style curves of its iron spandrels. Built in 1864 as a pedestrian path over the horse path, the arch has the less interesting official name of Bridge Number 28.

This view is from 250 feet (75 m) southwest, using the trees as a framing device and foreground.

✉ **Addr:**	W 94th Street, New York NY 10128	♀ **Where:**	40.788472 -73.962772
❓ **What:**	Bridge	☽ **When:**	Afternoon
👁 **Look:**	Northeast	W **Wik:**	Central_Park

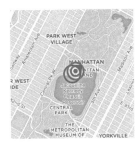

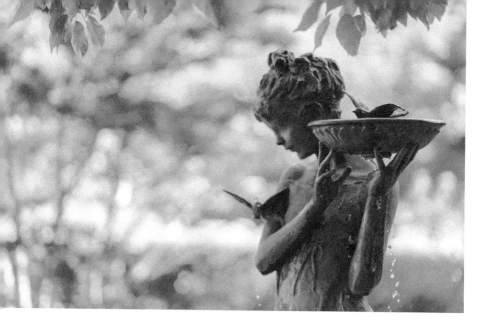

The **Conservatory Garden** is the only formal garden in Central Park. The south side features *The Secret Garden* water lily pool, dedicated in 1936 with a sculpture by Bessie Potter Vonnoh. The north side has the Untermyer Fountain with a cast of *Three Dancing Maidens* by Walter Schott in 1910.

✉ **Addr:**	E 104th Street, New York NY 10029	♀ **Where:**	40.793262 -73.952677
❓ What:	Formal garden	**⏾ When:**	Morning
👁 Look:	South-southwest	**W Wik:**	Conservatory_Garden

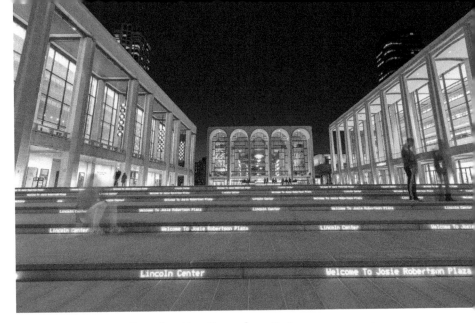

Lincoln Center for the Performing Arts is home to the
Metropolitan Opera, the New York City Ballet and the New York
Philharmonic. At the center is Revson Fountain, which makes a good
photo subject at night when it is lit from below.

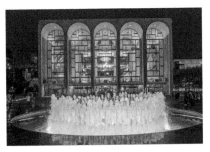 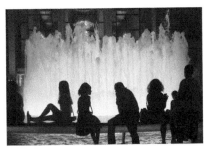

✉ **Addr:**	10 Lincoln Center Plaza, New York NY 10023	♀ **Where:**	40.772057 -73.98276	
❷ **What:**	Performing arts complex	◑ **When:**	Morning	
👁 **Look:**	West-northwest	W **Wik:**	Lincoln_Center_for_the_Performing_Arts	

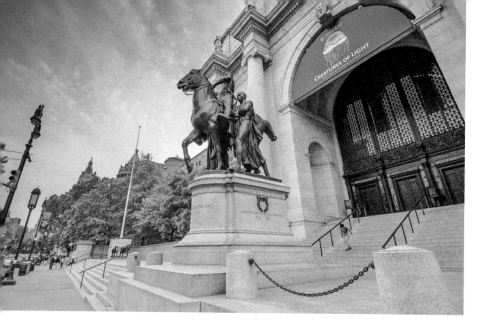

American Museum of Natural History is one of the largest
natural history museums in the world. The Beaux-Arts entrance on
Central Park West (above) is by John Russell Pope in 1936, and leads to
a vast Roman basilica with the skeleton of an Allosaurus (below).

A blue whale model hangs in the Ocean Life hall (below).

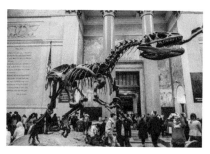 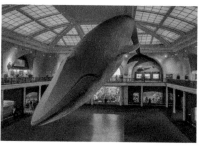

✉ **Addr:**	200 Central Park West, New York NY 10024	♀ **Where:**	40.780879 -73.972716	
❓ **What:**	Museum	◑ **When:**	Morning	
👁 **Look:**	West	W **Wik:**	American_Museum_of_Natural_History	

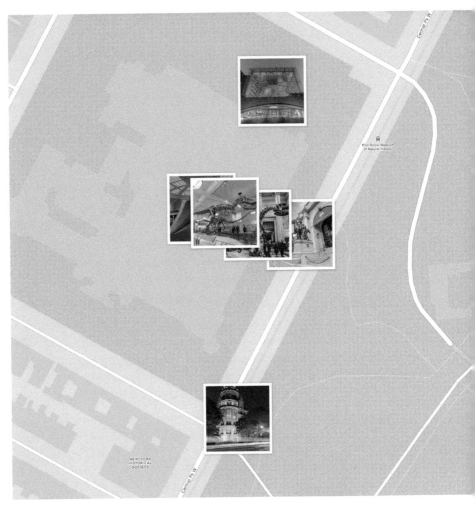

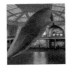

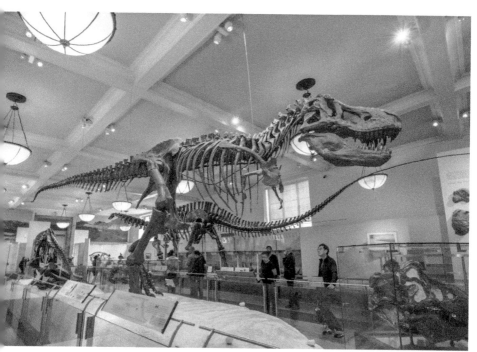

Above: The Hall of Saurischian Dinosaurs. Below: The Rose Center for Earth and Space is a six-story-high glass cube, on the north side of the museum complex, enclosing the spherical Hayden Planetarium.

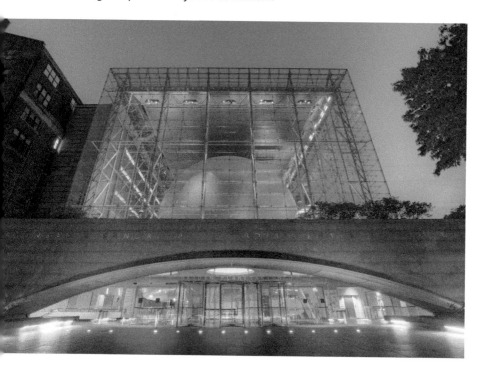

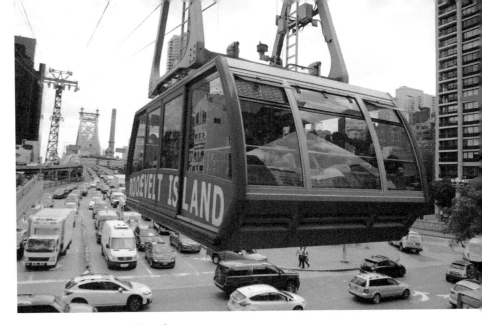

The **Roosevelt Island Tramway** is a gondola over the East River, between Manhattan Island and Roosevelt Island. Opened in 1976, the aerial tramway has two cabins that each run back and forth, suspended from their own pair of cables. From one cabin, you can photograph the other cabin over the river.

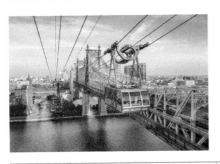
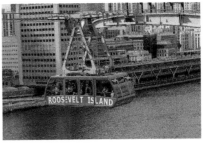

✉ **Addr:**	Second Ave at E 59th St, New York NY 10022	📍 **Where:**	40.761242 -73.964054
❓ **What:**	Gondola	🕐 **When:**	Afternoon
👁 **Look:**	South-southeast	Ⓦ **Wik:**	Roosevelt_Island_Tramway

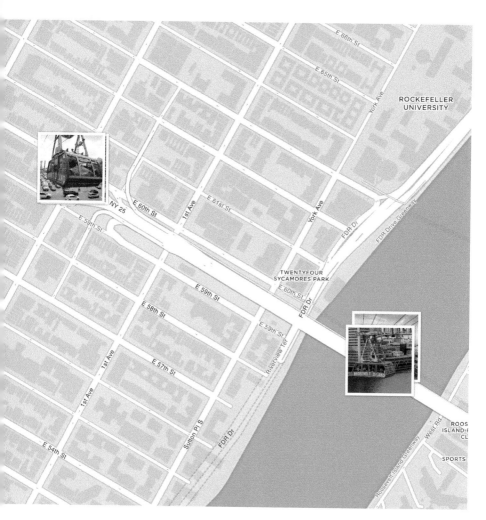

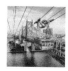

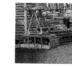

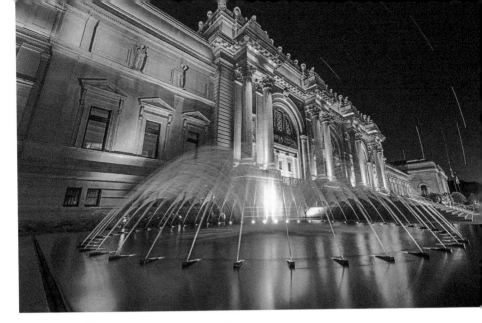

Metropolitan Museum of Art is the country's largest art museum. Known as "the Met", the museum is located in Central Park and faces the Upper East Side with a Beaux-Arts facade by architect and Met trustee, Richard Morris Hunt. Another Hunt design is the Grand Stairway (below). The rooftop garden has great views of Central Park.

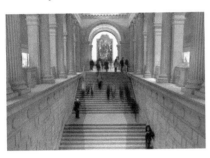

✉ **Addr:**	1000 5th Avenue, New York NY 10028	♀ **Where:**	40.7784868 -73.9626765
❷ **What:**	Museum	☾ **When:**	Morning
👁 **Look:**	Northwest	W **Wik:**	Metropolitan_Museum_of_Art

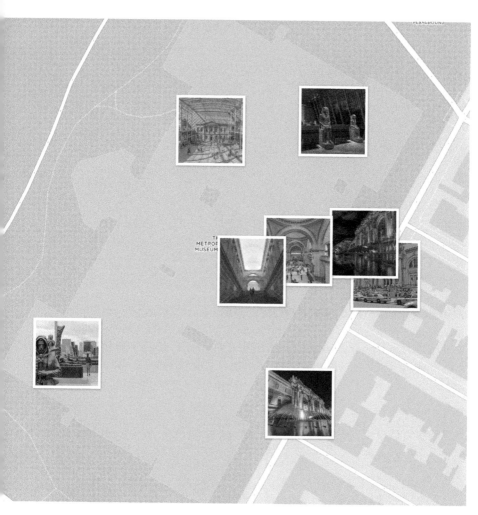

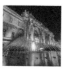

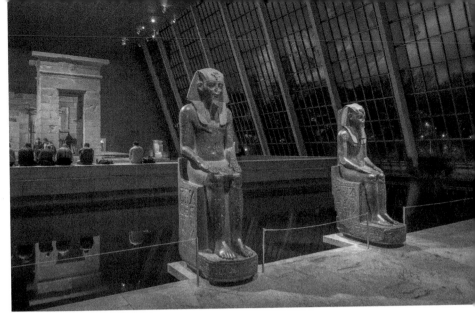

Above: The Temple of Dendur from 15BC was saved from the Aswan Dam in Egypt.

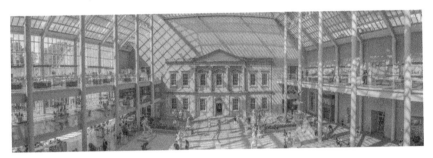

Above: The Charles Engelhard Court. Below: The Great Hall.

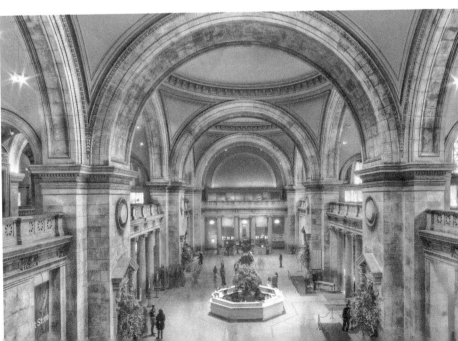

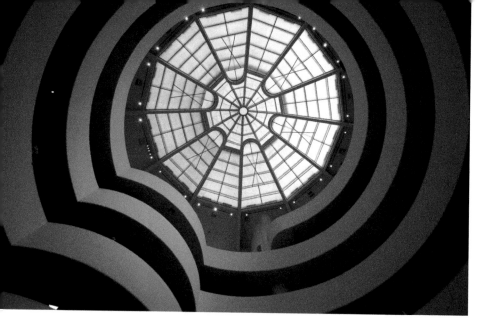

The **Guggenheim Museum** is a spiraling cylindrical building designed by Frank Lloyd Wright, opened in 1959. The atrium has a unique continuous ramp gallery, making five circles under a ceiling skylight.

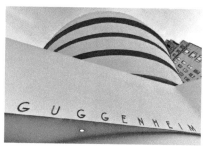
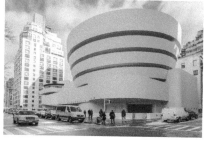

✉ **Addr:**	1071 5th Avenue, New York NY 10128	♀ **Where:**	40.783200 -73.959001
❷ **What:**	Museum	◐ **When:**	Morning
👁 **Look:**	South-southwest	W **Wik:**	Solomon_R._Guggenheim_Museum

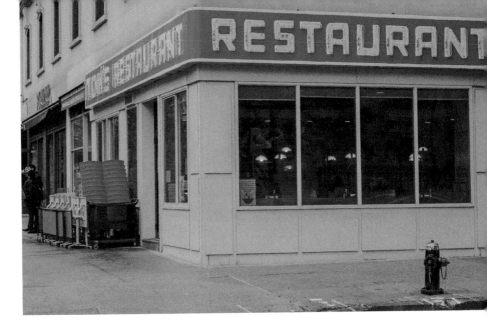

The **Seinfeld Diner** is where Jerry, George, Elaine and Kramer talked about nothing. Tom's Restaurant was used for the exterior scenes of Monk's Café in the popular 1990s television sitcom (filmed in California). Jerry's apartment is in Koreatown at 757 South New Hampshire Avenue, and the Friends apartment building is in Greenwich Village at 90 Bedford Street.

For your trivia quiz, Tom's Restaurant was also the inspiration for the 1981 Suzanne Vega song "Tom's Diner."

✉ **Addr:**	2880 Broadway, New York NY 10025	♀ **Where:**	40.805319 -73.965649
❷ **What:**	Restaurant	☽ **When:**	Afternoon
👁 **Look:**	East-northeast	W **Wik:**	Seinfeld

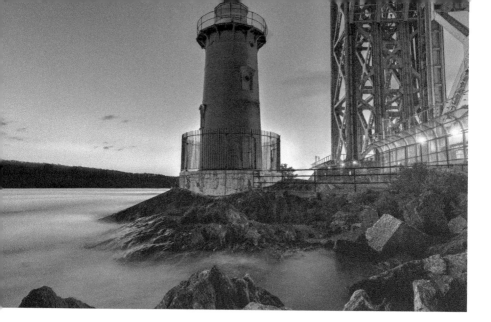

The **Little Red Lighthouse** was made famous in a 1942 children's book by Hildegarde Swift. Officially called Jeffrey's Hook Light, the 1921 tower stands under the George Washington Bridge in Fort Washington Park, on the northern tip of Manhattan. Access is by a footbridge at West 158th Street.

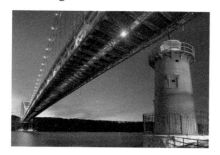

✉ **Addr:**	Fort Washington Park, New York NY 10033	📍 **Where:**	40.850046 -73.946974	
❓ **What:**	Lighthouse	🌓 **When:**	Anytime	
👁 **Look:**	North	W **Wik:**	Little_Red_Lighthouse	

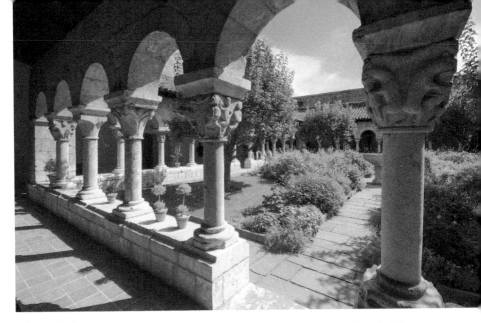

The Cloisters is a museum designed to resemble a medieval abbey. The buildings are centered around four cloisters from France, which were purchased and moved to New York. The Gothic chapel was built to display 14th century stained glass windows.

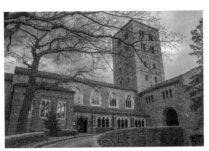
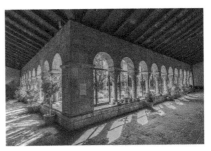

✉ **Addr:**	99 Margaret Corbin Drive, New York NY 10040	♀ **Where:**	40.864959 -73.931841
❷ **What:**	Building	☽ **When:**	Morning
👁 **Look:**	South-southwest	W **Wik:**	The_Cloisters

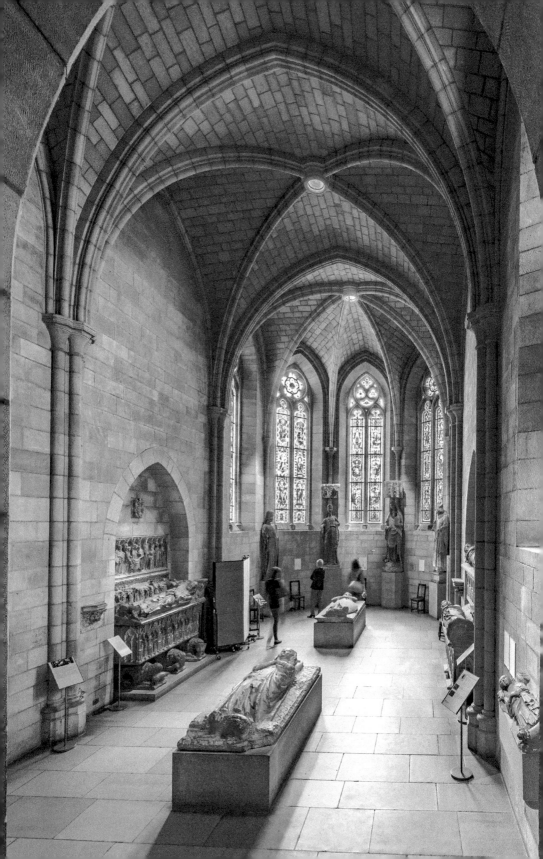

The **Bronx Zoo** is one of the largest zoos in the United States by area, comprising 265 acres (107 ha) of park lands. Founded in 1895 and first opened in 1899, the zoo is located in Bronx Park, by the New York Botanical Garden.

✉ **Addr:**	2300 Southern Blvd, Bronx NY 10460	📍 **Where:**	40.850581 -73.87538
❓ **What:**	Zoo	⏱ **When:**	Afternoon
👁 **Look:**	North	W **Wik:**	Bronx_Zoo

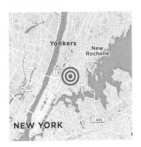
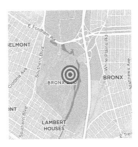

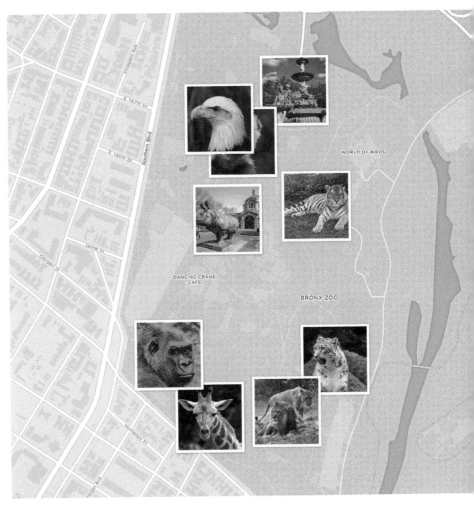

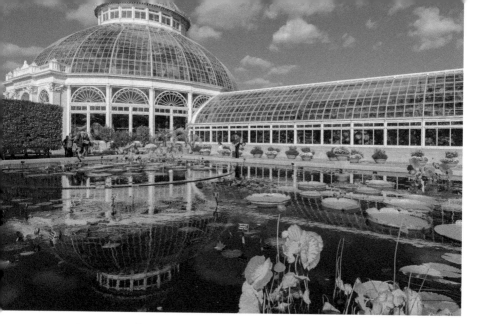

The **New York Botanical Garden** is a 250-acre (100 ha) garden inspired by the Royal Botanic Gardens in London. Highlights are the Victorian "crystal-palace style" greenhouse and the Mertz Library, both from 1891, and an old-growth forest from before the arrival of European settlers in the 17th century.

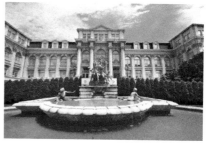

✉ **Addr:**	2900 Southern Boulevard, Bronx NY 10458	♀ **Where:**	40.86342 -73.881885
❓ **What:**	Botanical garden	◑ **When:**	Morning
👁 **Look:**	North	W **Wik:**	New_York_Botanical_Garden

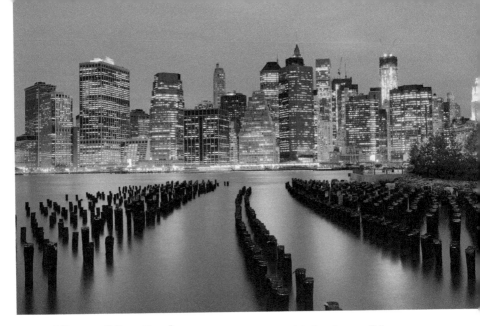

Brooklyn Bridge Park in Brooklyn has multiple views of the Manhattan skyline. These shots are from south of Pier 1, using old pier stubs as leading lines.

The Promenade on Pier 1 has a view north of the Brooklyn Bridge and the Manhattan Bridge.

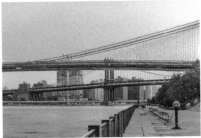

✉ **Addr:**	Brooklyn Bridge Park, Brooklyn NY 11201	♀ **Where:**	40.7008039 -73.9968342	
◑ **When:**	Morning	◉ **Look:**	West-northwest	
↔ **Far:**	0.89 km (0.56 miles)			

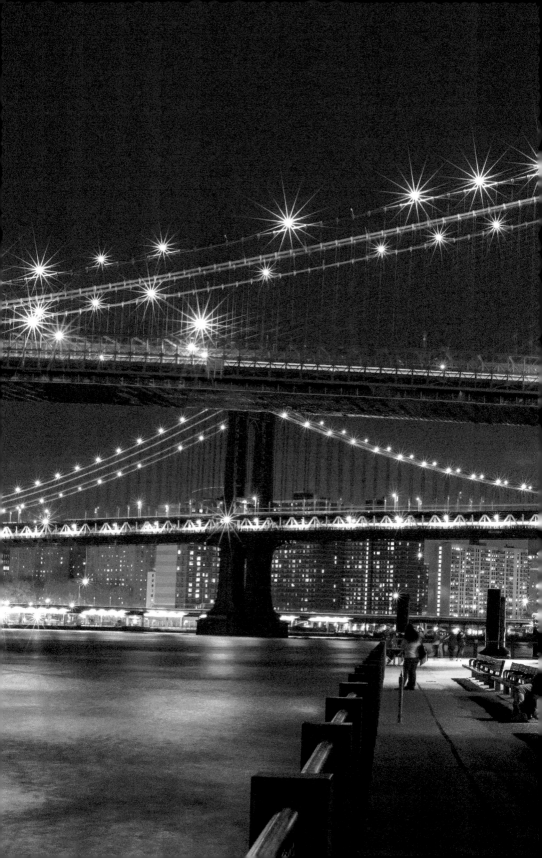

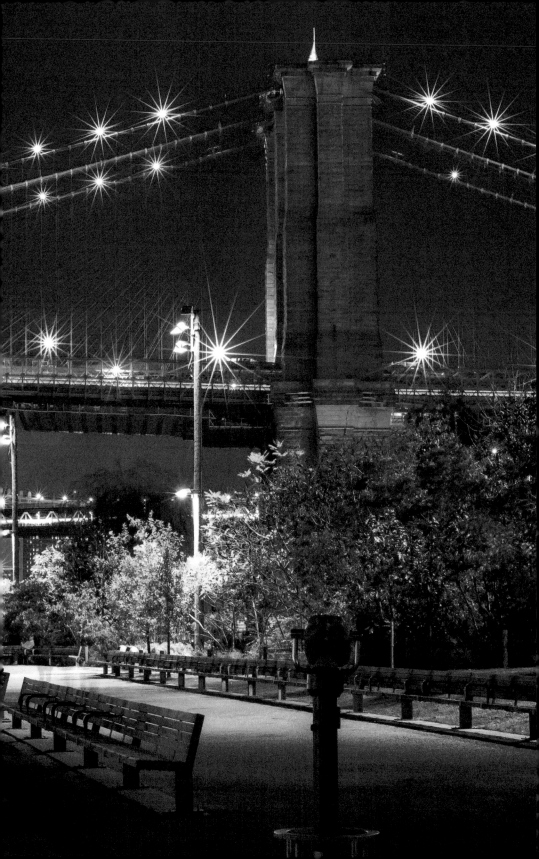

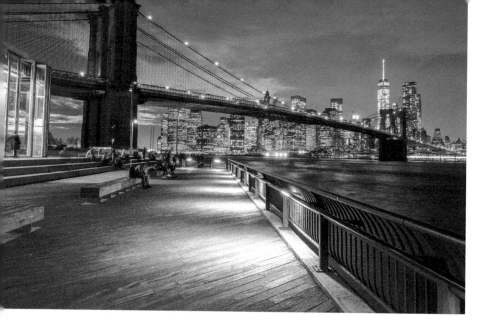

Empire Fulton Park, which is part of Brooklyn Bridge Park, has a wooden boardwalk with views of the Brooklyn Bridge and One World Trade Center. Housed in a glass-walled pavilion is Jane's Carousel, built in 1922 with 48 carved wooden horses.

✉ **Addr:**	Brooklyn Bridge Park, Brooklyn NY 11201	♀ **Where:**	40.704627 -73.992215	
◑ **When:**	Morning	◉ **Look:**	West	
W **Wik:**	Brooklyn_Bridge_Park#Empire-Fulton_Ferry			

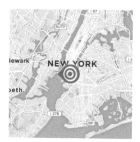
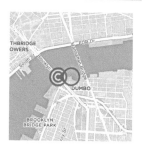

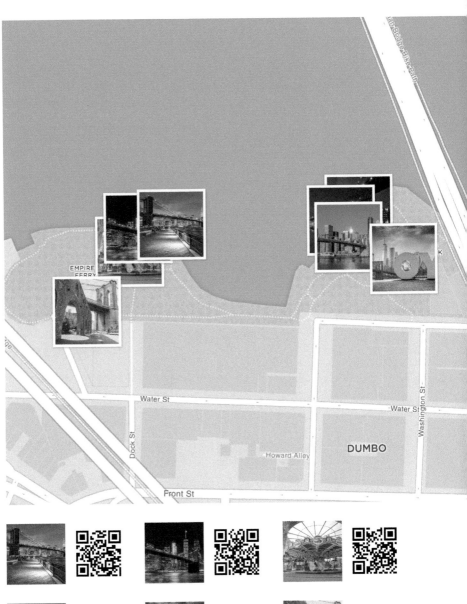

EMPIRE
FERRY

Water St

Water St

Dock St

Washington St

DUMBO

Howard Alley

Front St

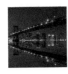

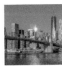

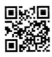

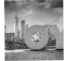

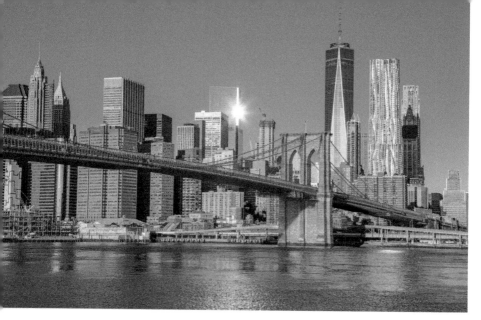

Above: Main Street Park has views of the Brooklyn Bridge ...

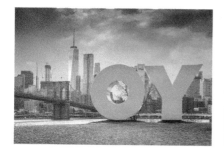 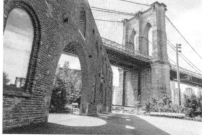

... and the Manhattan Bridge. Above: St. Ann's Warehouse.

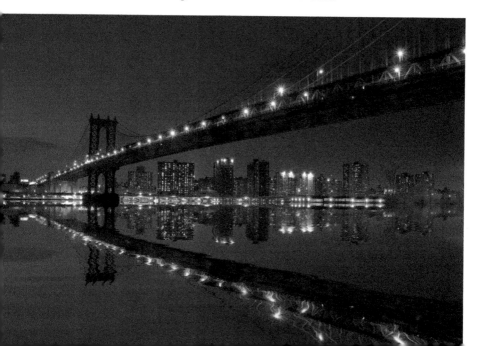

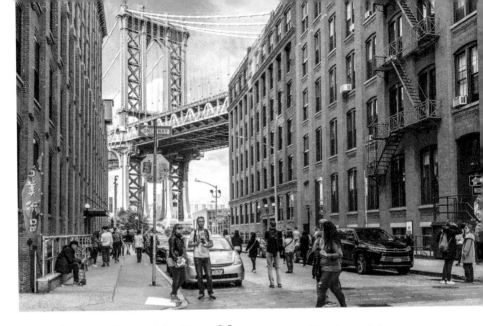

Washington Street in Brooklyn has a terrific view of the Manhattan Bridge. Red brick warehouses and the Belgian block paving lead the eye to the 336 ft (102 m) high steel tower. If you stand just right you can get the Empire State Building framed in the bridge's lower arch.

The cross street here is Water Street, in the Dumbo section of in Brooklyn. Dumbo is short for Down Under the Manhattan Bridge Overpass.

Another piece of trivia: the cardboard box was invented one block south, in the Gair Building at 70 Washington Street. One more block south, at Prospect Street, is the stairs entrance to Brooklyn Bridge Promendade.

✉ **Addr:**	40 Washington St, Brooklyn NY 11201	📍 **Where:**	40.703145 -73.989559
🕐 **When:**	Afternoon	👁 **Look:**	North
W **Wik:**	Dumbo,_Brooklyn		

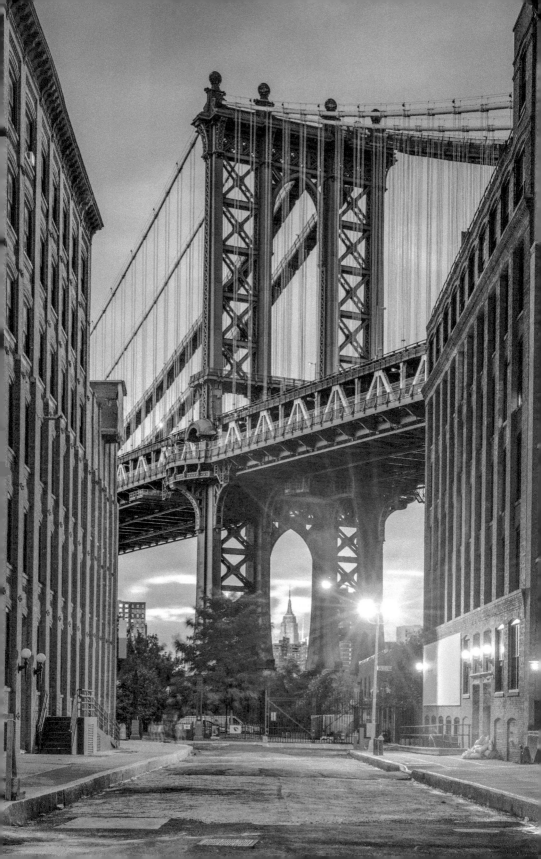

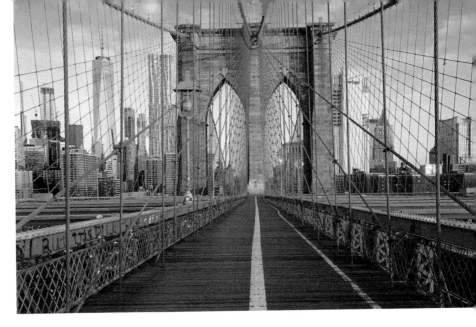

Brooklyn Bridge Promenade is a pedestrian boardwalk above the traffic on the iconic span. From the Brooklyn side, you can capture Manhattan in the background, behind a gorgeous symmetric web-like pattern of cables that draws the eye into the picture.

Access via stairs in Brooklyn is from 130 Cadman Plaza East at Prospect Street, at the base of Washington Street.

Opened in 1883, Brooklyn Bridge is one of the oldest roadway bridges in the United States and was the world's first steel-wire suspension bridge. It was conceived by German immigrant John Augustus Roebling, and designed by his son and daughter-in-law, Washington and Emily Warren Roebling.

✉ **Addr:**	Brooklyn Bridge Promenade, Brooklyn NY 11201	♥ **Where:**	40.70346 -73.99356
◑ **When:**	Morning	◉ **Look:**	Northwest
W **Wik:**	Brooklyn_Bridge		

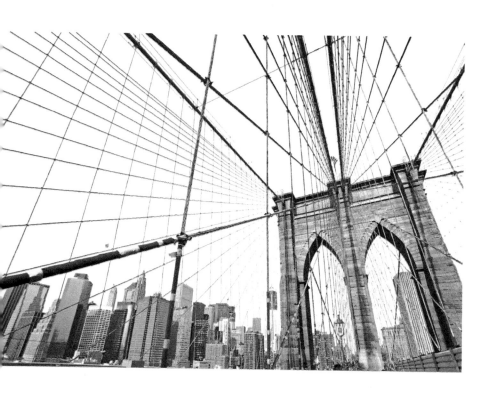

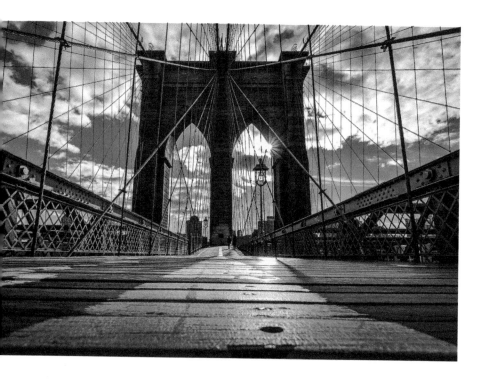

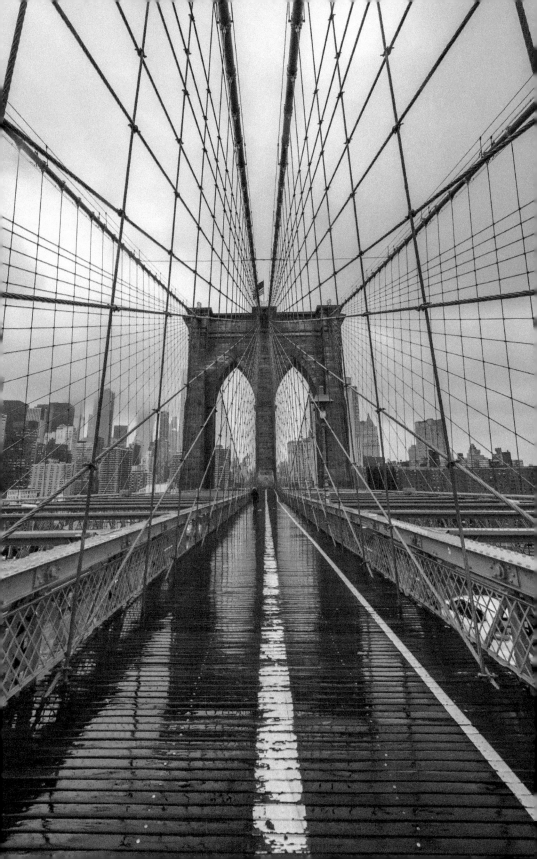

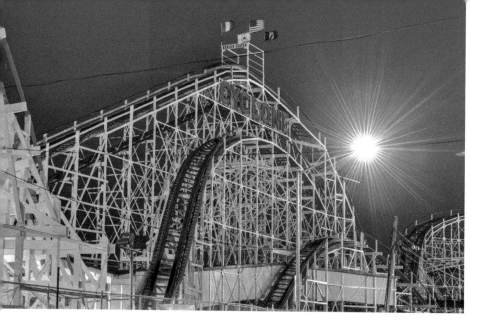

Coney Island is seaside resort with a beach, boardwalk and amusement park. What was once "Rabbit Island" was connected by land fill to Long Island and became a Brooklyn neighborhood.

The **Coney Island Cyclone**, opened in 1927, is perhaps the best known historical roller coaster.

✉ **Addr:**	801 Riegelmann Boardwalk, Brooklyn NY 11224	♀ **Where:**	40.5751954 -73.9779268
❷ **What:**	Rollercoaster	◑ **When:**	Afternoon
👁 **Look:**	South-southeast	W **Wik:**	Coney_Island_Cyclone

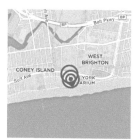

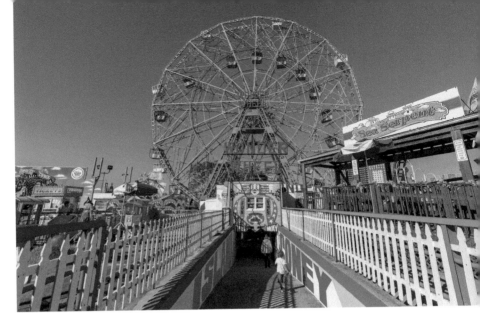

Wonder Wheel is a 45.7-metre (150 ft) tall Ferris wheel, with some cars that slide along tracks. Opened in 1920, the ride is the centerpiece of Deno's Wonder Wheel Amusement Park, which overlooks the Atlantic Ocean and the 2.7-mile (4.3 km) long Riegelmann Boardwalk.

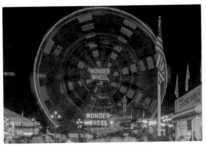

✉ **Addr:**	3058 Jones Walk, Brooklyn NY 11224	♀ **Where:**	40.573707 -73.979166
❓ **What:**	Ferris wheel	◑ **When:**	Afternoon
👁 **Look:**	North	W **Wik:**	Wonder_Wheel

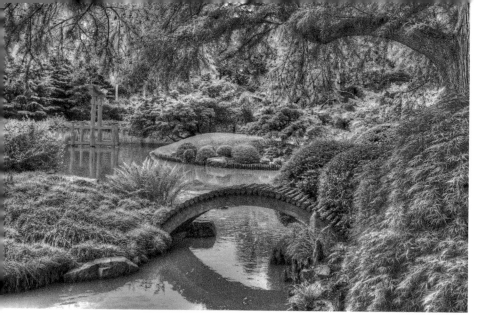

The **Japanese Hill-and-Pond Garden** was the first Japanese garden to be created in an American public garden. Opened in 1915, and considered to be the masterpiece of its creator, Japanese landscape designer Takeo Shiota, the Garden is part of the Brooklyn Botanic Garden in Brooklyn's Mount Prospect Park.

✉ **Addr:**	990 Washington Ave, Brooklyn NY 11225	♀ **Where:**	40.66899 -73.962993
❓ **What:**	Garden	☽ **When:**	Afternoon
👁 **Look:**	South	Ⓦ **Wik:**	Brooklyn_Botanic_Garden

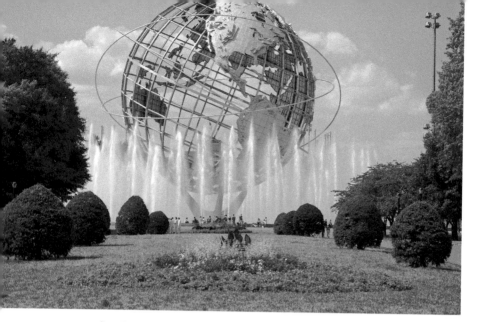

The **Unisphere** is the world's largest globe, with a diameter of 120 feet (37 m). Commissioned to celebrate the beginning of the space age for the 1964 New York World's Fair, the stainless steel structure (and other Fair artwork) is located in Flushing Meadows–Corona Park in the New York City borough of Queens.

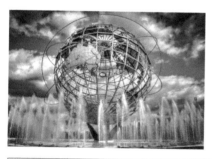
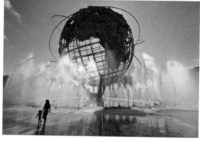

✉ **Addr:**	11101 Corona Avenue, Queens NY 11368	♥ **Where:**	40.746015 -73.844548	
❓ **What:**	Sculpture	☽ **When:**	Morning	
👁 **Look:**	Northwest	W **Wik:**	Unisphere	

Fountain of
the
Continents

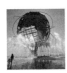 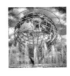 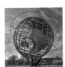

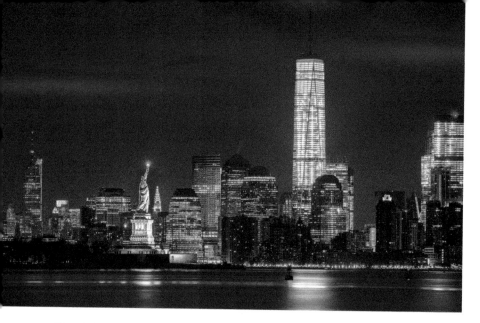

Port Jersey in Jersey City has a view of the Statue of Liberty and One World Trade Center. The container terminal has a public walkway along its northern side and the tip of the pier is 1.76 miles (2.8 km) SSW of Liberty Island. At such a long range, a tripod is necessary to get a sharp dusk shot.

Driving from One WTC to here is about 10 miles, across the Hudson River and down I-78 in New Jersey.

✉ **Addr:**	Port Jersey Blvd, Jersey City NJ 07305	♀ **Where:**	40.669002 -74.065319
☾ **When:**	Anytime	☻ **Look:**	Northeast
W **Wik:**	Port_Jersey		

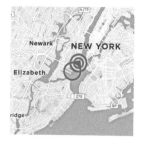

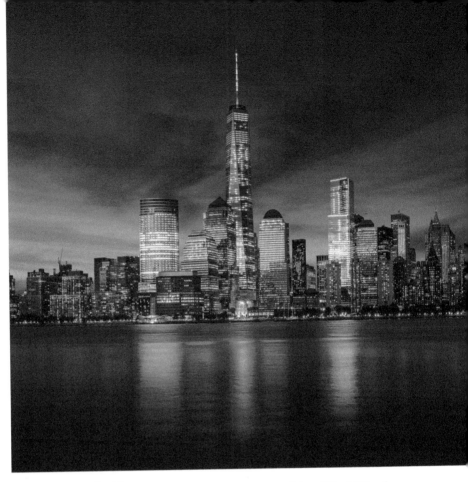

Paulus Hook Pier in Jersey City has a view of One World Trade Center and Lower Manhattan, one mile (1.6 km) to the east. You catch a ferry to the pier and back from Battery Park City, by the Irish Hunger Memorial.

✉ **Addr:**	30 Hudson St, Jersey City NJ 07302	📍 **Where:**	40.7136293 -74.0319027
◑ **When:**	Anytime	👁 **Look:**	East
W **Wik:**	Exchange_Place_(Jersey_City)		

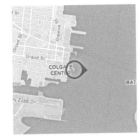
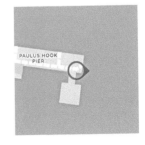

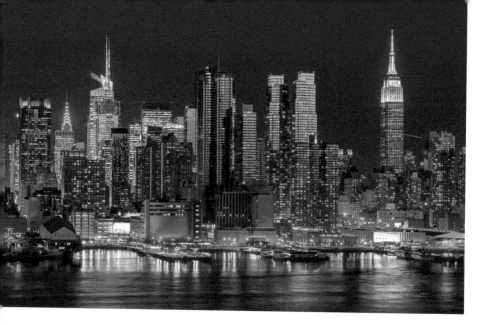

The **Weehawken Waterfront** has a view of the west side of Midtown Manhattan, with the Empire State Building and the piers of Hudson River Park.

You can drive to here from Manhattan through the Lincoln Tunnel at W 39th Street, or reach similar viewpoints by the two Weehawken ferries from Pier 78, at the end of W 38th Street.

✉ **Addr:**	Weehawken Waterfront, Weehawken NJ 07086	♀ **Where:**	40.770405 -74.014636	
❓ **What:**	Skyline	☾ **When:**	Anytime	
👁 **Look:**	East-southeast	W **Wik:**	Weehawken,_New_Jersey	

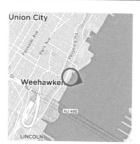
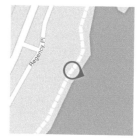

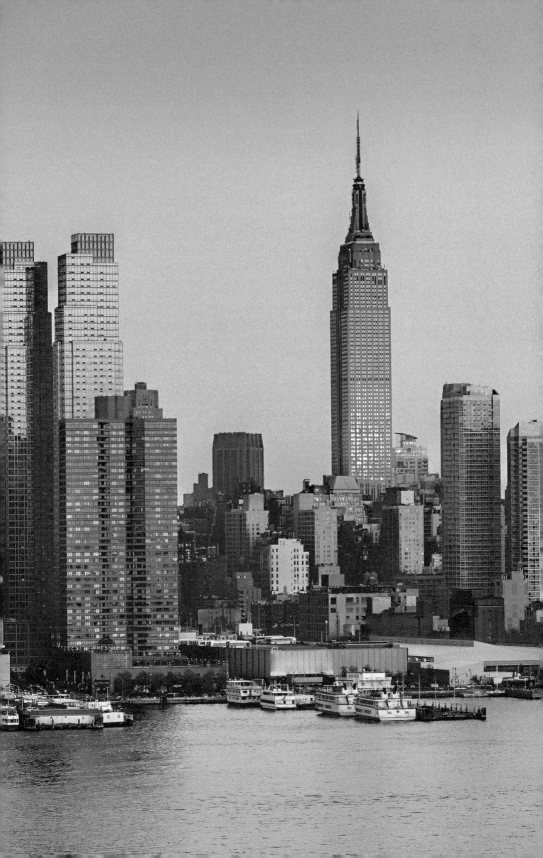

Credits

Thank you to the many wonderful people and companies that made their work available to use in this guide.

Photo key: The number is the page number. The letters reference the position on the page, the distributor and the license. Key: a:CC-BY-SA; b:bottom; c:center; d:CC-BY-ND; e:CC-PD; f:Flickr; h:Shutterstock standard license; l:public domain; o:CC0; q:Pixabay; s:Shutterstock; t:top; w:Wikipedia; y:CC-BY.

Cover image by Sebastien Burel/Shutterstock. Back cover image by Alarax/Shutterstock. Aeypix (18b sh); Jack Aiello (146, 146 sh); Anderm (53 sh); John A. Anderson (117, 128 qo); Armelion (18 sh); Astudio (47 sh); Ruben Martinez Barricarte (93t wa); Carmelo Bayarcal (135 sh); Andrey Bayda (44 wy); Jean-christophe Benoist (43 wa); Bestbudbrian (93, 93 sh); Bigmacsc99 (22 sh); Jon Bilous (44, 61c, 107, 126 sh); Andriy Blokhin (54t sh); Kristi Blokhin (58t, 58, 153t sh); Blvdone (166t sh); Goran Bogicevic (72 sh); Stephen Bonk (113 sh); Samuel Borges Photography (89 sh); Sebastien Burel (23 sh); Daniele Carotenuto (152 sh); Joaquin Ossorio Castillo (86 sh); Paper Cat (98t sh); Chameleonseye (24, 26 fa); Julien Chatelain (138t wa); Chensiyuan (27 sh); Ece Chianucci (124t sh); Jon Chica (46 fe); Jody Claborn (43t sh); Benjamin Clapp (143 sh); Sylvie Corriveau (92 fy); Chris Costello (144b sh); Rob Crandall (29 sh); Erika Cross (70 sh); Robert Crum (96t sh); Curtis (135t wl); Daderot (125 wa); Dansnguyen (79c sh); Bumble Dee (31b sh); Alexander Demyanenko (34t sh); Songquan Deng (104, 113, 113b fy); Vincent Desjardins (39 sh); Tamer Desouky (144t sh); Dibrova (33t, 100b wy); Francisco Diez (123t, 123b sh); Dw_labs (39t sh); Eileen_10 (125t sh); Eqroy (60t sh); F11photo (39, 112t, 119t wa); Tomás Fano (115 fa); Toms Fano (104 fy); Jerry Ferguson (106 sh); Sarah Fields Photography (126t wa); Flapane (162t sh); Zack Frank (30t qo); Free-photos (18t fy); Jochen Frey (89 sh); Florentino Ar G (53 sh); Gaborvincze (152 sh); Maurizio Gaeta (141 sh); Gagliardiimages (121t sh); Gagliardiphotography (86t, 92 wa); Geraldshields11 (37 sh); Simone Gramegna (157 sh); Diego Grandi (130, 132t, 137t fy); Son Of Groucho (96 sh); Linda Harms (160t, 160, 161 wa); King Of Hearts (146t fa); Ana Paula Hirama (22b fa); Hobbs_luton (90 sh); Holbox (20 sh); Matej Hudovernik (15t sh); Manuel Hurtado (141t sh); Eastvillage Images (96 sh); Im_photo (69, 165t sh); Dw Labs Incorporated (63, 78t, 120 sh); Industryandtravel (49 wa); Ingfbruno (123, 126 sh); Inolas (74 wy); Joi Ito (62t sh); Itzavu (137c sh); J2r (57 sh); Gerd Jacobs (24t sh); Javen (73, 116 sh); Shaun Jeffers (39 sh); Jjfarq (57t, 58 sh); Joeyhoogendoorn (60 sh); Kamira (33, 39, 46, 104b sh); Kridsada Kamsombat (116 wa); Beyond My Ken (74 sh); Bill Kennedy (143 sh); Tanat Khemthongpradit (52b sh); Brian Kinney (59t sh); James Kirkikis (26 sh); Mikhail Kolesnikov (120t wa); Koushikrishnan (107t sh); Kropic1 (19t, 49 sh); Emin Kuliyev (110 sh); Lamiafotografia (78b sh); Philip Lange (27t sh); David W. Leindecker (143 wa); Rich Lemonie (27t sh); Felix Lipov (35, 98, 138, 158t, 158, 159t, 159, 162 sh); Littlenystock (104t, 150, 143 sh); Mike Liu (152b sh); Brian Logan Photography (35 sh); Mariusz Lopusiewicz (46 sh); Louielea (143t, 143, 143 sh); Luciano Mortula - Lgm (16, 156t sh); Mandritoiu (68t, 164t sh); Maridav (147 sh); Victor Maschek (22t sh); Clari Massimiliano (130 fy); Matheuslotero (18c sh); Maurizio de Mattei (97 fy); Giuseppe Milo (156b sh); Mishella (41 sh); Stuart Monk (39, 41t, 71, 87, 115t sh); Teresa Moore (49, 111 sh); Giuliano Del Moretto (31 sh); Luciano Mortula (80t, 81, 91t, 91 sh); Mtnardi (30b sh); Resul Muslu (55, 57, 111t wl); Maarten Van Den Heuvel Mvdheuvel (106 sh); Nattyc (51 sh); Njene (133t, 133, 133, 133, 133 sh); Nuchie (52t sh); Byelikova Oksana (140t, 140 sh); Andrei Orlov (129t sh); Pabkov (70 sh); Chris Parypa Photography (101t sh); Tracey Patterson (30 sh); Pavelmw (31t sh); Sean Pavone (30, 34, 37t, 38t, 38, 43, 44t, 46b, 65c, 66t, 67t, 73t, 92t, 108t, 113t, 116t, 130t, 130, 132b, 147t, 154 sh); Christopher Penler (49 fy); David Phan (89b sh); Photo_ua (109t sh); Pitk (48t, 49 fy); Prayitno (90t sh);

Alexander Prokopenko (102 wa); Ps2avery (162 sh); Quietbits (41 wy); Anthony Quintano (106t sh); Lev Radin (82t, 83t, 83b, 84 wy); Phillip Ritz (62 sh); Will Rodrigues (127t sh); Rolf_52 (139t sh); Francois Roux (53, 57b, 68, 76t, 76, 78, 78, 79t, 82 sh); Tinnaporn Sathapornnanont (138 sh); Alfredo Garcia Saz (35, 75 sh); S.borisov (123 sh); R Scapinello (42 fy); Rebecca Schear (119b wa); Daniel Schwen (26b sh); Siso Seasaw (135 sh); Shanshan0312 (35t, 35 sh); Keith Sherwood (162 sh); Daniel M. Silva (105 sh); Marcio Silva (110t sh); Marcio Jose Bastos Silva (94b sh); Mihai Simonia (86 sh); Lee Snider (129 sh); Solepsizm (79b wa); Sracer357 (137b sh); Nick Starichenko (64t, 74t fd); A. Strakey (60 sh); Studiolaska (128t sh); Page Light Studios (135 sh); T Photography (128 sh); Taiga (152t sh); Luboslav Tiles (98 sh); Tooykrub (47t sh); Travelview (94t, 129, 141, 142 sh); Benson Truong (38 sh); Ttstudio (106b, 155t sh); Tupungato (66 sh); By Ua (100t sh); Ubjsp (22 sh); Ungvar (150 sh); Michele Vacchiano (70t sh); Holly Vegter (72t sh); Pavel L Photo And Video (46t wa); Villagehero (89 fy); Aaron Vowels (27 sh); Stas Walenga (147, 148 sh); Luis War (35 sh); Jannis Tobias Werner (68 sh); Woodysphotos (129 sh); Zoltan.benyei (150t sh).

Some text adapted from Wikipedia and its contributors, used and modified under Creative Commons Attribution-ShareAlike (CC-BY-SA) license. Map data from OpenStreetMap and its contributors, used under the Open Data Commons Open Database License (ODbL).

This book would not exist without the love and contribution of my wonderful wife, Jennie. Thank you for all your ideas, support and sacrifice to make this a reality. Hello to our terrific kids, Redford and Roxy.

Thanks to the many people who have helped PhotoSecrets along the way, including: Bob Krist, who answered a cold call and wrote the perfect foreword before, with his wife Peggy, becoming good friends; Barry Kohn, my tax accountant; SM Jang and Jay Koo at Doosan, my first printer; Greg Lee at Imago, printer of my coffe-table books; contributors to PHP, WordPress and Stack Exchange; mentors at SCORE San Diego; Janara Bahramzi at USE Credit Union; family and friends in Redditch, Cornwall, Oxford, Bristol, Coventry, Manchester, London, Philadelphia and San Diego.

Thanks to everyone at distributor National Book Network (NBN) for always being enthusiastic, encouraging and professional, including: Jed Lyons, Jason Brockwell, Kalen Landow (marketing guru), Spencer Gale (sales king), Vicki Funk, Karen Mattscheck, Kathy Stine, Mary Lou Black, Omuni Barnes, Ed Lyons, Sheila Burnett, Max Phelps and Les Petriw. A special remembrance thanks to Miriam Bass who took the time to visit and sign me to NBN mainly on belief.

The biggest credit goes to you, the reader. Thank you for (hopefully) buying this book and allowing me to do this fun work. I hope you take lots of great photos!

© Copyright

PhotoSecrets New York, first published May 15, 2019. This version output April 14, 2019.

ISBN: 978-1930495623. Distributed by National Book Network. To order, call 800-462-6420 or email customercare@nbnbooks.com.

> *"'And what is the use of a book,' thought Alice*
> *'without pictures or conversations?'"*
> *— Alice's Adventures in Wonderland, Lewis Carroll*

© Copyright

🔨 Disclaimer

The information provided within this book is for general informational purposes only. Some information may be inadvertently incorrect, or may be incorrect in the source material, or may have changed since publication, this includes GPS coordinates, addresses, descriptions and photo credits. Use with caution. Do not photograph from roads or other dangerous places or when trespassing, even if GPS coordinates and/or maps indicate so; beware of moving vehicles; obey laws. There are no representations about the completeness or accuracy of any information contained herein. Any use of this book is at your own risk. Enjoy!

✉ Contact

For corrections, please send an email to andrew@photosecrets.com. Instagram: photosecretsguides; Web: www.photosecrets.com

Index

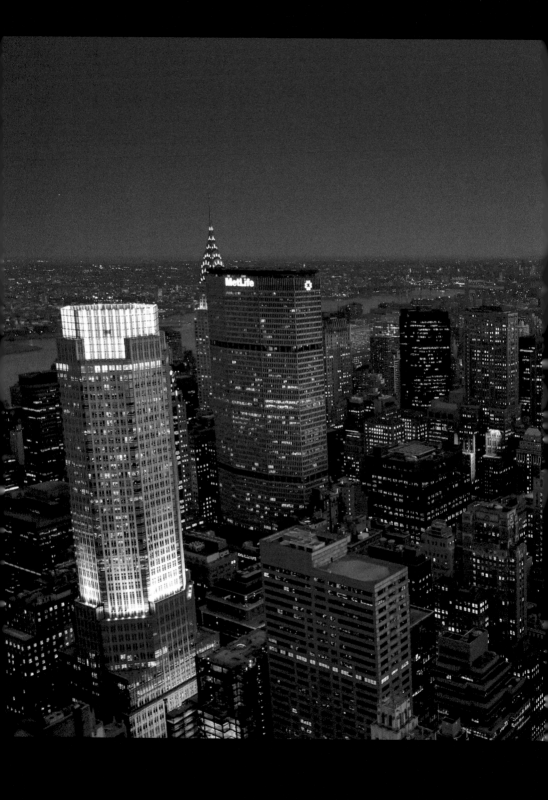

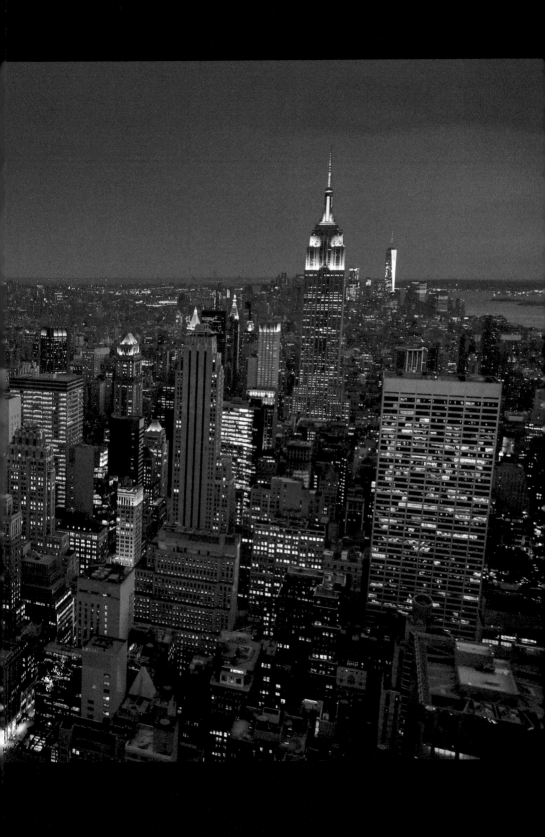

Welcome

THANK YOU for reading PhotoSecrets. I like to start books by flicking from the back cover, so this is a good place for a welcome message.

As a fellow fan of travelling with a camera, I hope this guide will quickly get you to the best spots so you can take postcard-perfect pictures.

PhotoSecrets shows you all the best sights. Look through, see the classic shots, and use them as a departure point for your own creations. Get ideas for composition and interesting viewpoints. See what piques your interest. Know what to shoot, why it's interesting, where to stand, when to go, and how to get great photos.

Now you can spend less time researching and more time photographing.

The idea for PhotoSecrets came during a trip to Thailand, when I tried to find the exotic beach used in the James Bond movie *The Man with the Golden Gun*. None of the guidebooks I had showed the beach, so I thought a guidebook of postcard photos would be useful. Twenty-plus years later, you have this guide, and I hope you find it useful.

Take lots of photos!

Andrew Hudson

Andrew Hudson started PhotoSecrets in 1995 and has published 21 nationally-distributed color photography books. His first book won the Benjamin Franklin Award for Best First Book and his second won the Grand Prize in the National Self-Published Book Awards.

Andrew has photographed assignments for *Macy's*, *Men's Health* and *Seventeen*, and was a location scout for *Nikon*. His photos and articles have appeared in *National Geographic Traveler*, *Alaska Airlines*, *Shutterbug*, *Where Magazine*, and *Woman's World*.

Born in England, Andrew has a degree in Computer Engineering from the University of Manchester and was previously a telecom and videoconferencing engineer. Andrew and his wife Jennie live with their two kids and two chocolate Labs in San Diego, California.

176 PhotoSecrets New York